BULKINGTON

THROUGH TIME

John Burton

John Burton

1 June 2013

AMBERLEY PUBLISHING

First published 2013

Amberley Publishing
The Hill, Stroud
Gloucestershire, GL5 4EP

www.amberley-books.com

Copyright © John Burton, 2013

The right of John Burton to be identified as the
Author of this work has been asserted in accordance
with the Copyrights, Designs and Patents Act 1988.

ISBN 978 1 84868 754 7

British Library Cataloguing in Publication Data.
A catalogue record for this book is available from
the British Library.

Typeset in 9.5pt on 12pt Celeste.
Typesetting by Amberley Publishing.
Printed in the UK.

Introduction

Much has changed since 1990 when *Around Bulkington in Old Photographs* was published: not only in the appearance of the village but also in the way that books are published. A generation has grown up with no memories of what Chequer Street, Leicester Street or Ryton looked like, so the idea of using past as well as present photographs, in colour, to explain to that generation what changes have taken place in their village and their community was not to be missed.

Many compromises were made in the selection. I could not include as many old pictures in the format provided, and every new photograph means an old one goes. So there are fewer pictures of groups and community events, sport is not included, and many colourful events I would love to include, like flower festivals, garden displays, church events, pub and club scenes all had to go.

I felt it important to establish a clear narrative in the book to enable readers to be guided through the village as it is, and to see in the pages of the book what it used to be. I wanted as much information as possible in the captions, bearing in mind the restrictions imposed by format and design. I wanted to capture some of what makes Bulkington special and unique. It is the largest village in Warwickshire, large enough for schools, for the Village Centre and the library, as well as four churches and seven pubs and clubs.

Reading that list raises the question of the future of the village, for its population and facilities rival many small towns. Indeed the shops in Leicester Street look like a suburban shopping centre rather than a village. There is little employment in the village and people work in Nuneaton, Coventry or elsewhere. Government relaxation of planning restrictions might mean new housing on the edge of the village. The future will be challenging for residents. Do we remain a village or become a small town? My feeling is that the village strongly wishes to remain a village. One still hears people in the street and in the shops refer to 'the village' and they speak of it with fierce pride, which is shown in practical ways like the support for the carnival, for the Christmas lights, for the library and for the Village Centre. I have put the opening of the community library on the back cover of the

book because it displayed local determination not to be dictated to by Warwick about whether we had a library or not.

Reference is made in this book to our great local writer, George Eliot, and her family connections at Marston Jabbett. In one of her first short stories, 'Mr Gilfil's Love Story', there is a wonderful, eccentric old lady called Dame Fripp, who on warm summer evenings liked to recline in the dry ditch accompanied by her pig, which rested its head on her lap and contributed the occasional grunt to proceedings.

The picture below could be Dame Fripp's pig emerging from his sty. I invite you to let him accompany us round the village and to see him safely back in his sty at the end!

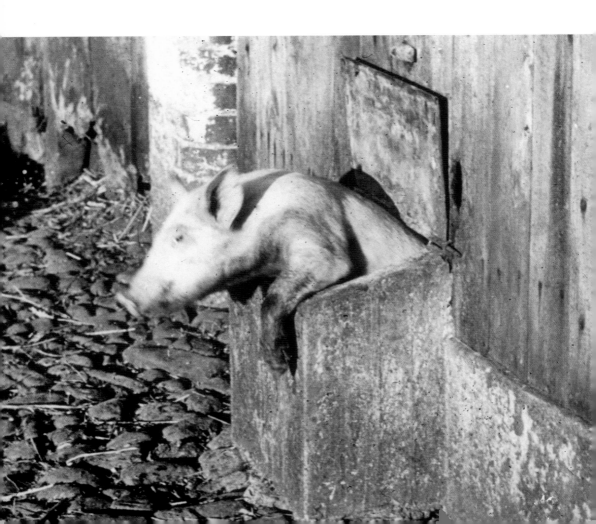

A Walk Through the Village

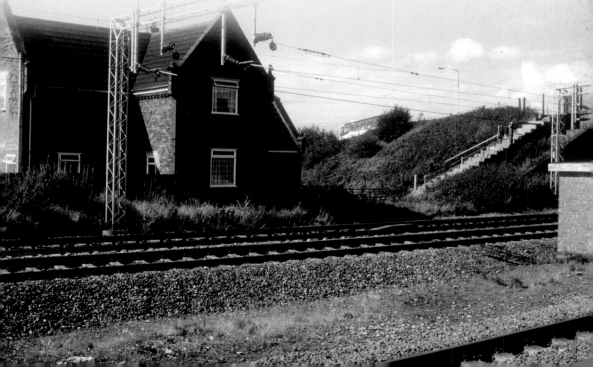

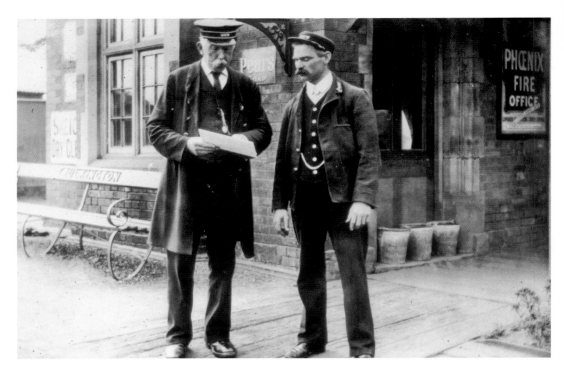

The Railway Age

Bulkington once had a railway station. On page 5 we see it in use, with passengers on the platform. What remains now is a private house close to a busy main line. The 1907 picture on this page shows stationmaster Turner posing with one of his staff in their LNWR uniform. Turner retired in 1909. Nowadays Virgin trains hurtle through the countryside, but as one passes we can still see the name Bulkington on the wall.

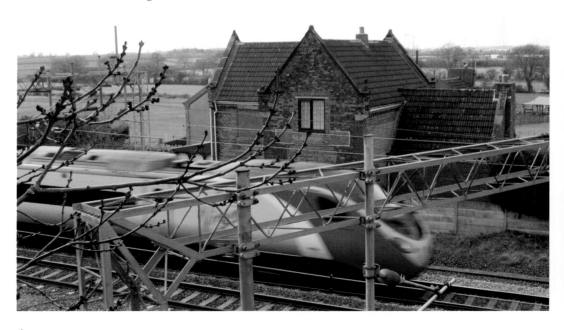

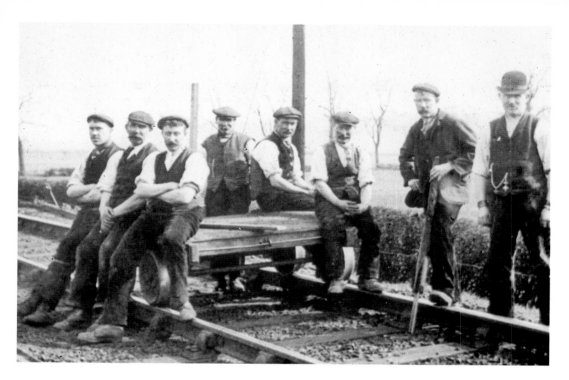

Railway Maintenance

Maintaining the track has always been a key part of safety on the railways. The pictures show a maintenance gang from early in the last century, when picks and shovels were the order of the day, somewhere near Bulkington and, below, the virtual rebuilding of the embankment close to the Coventry Road bridge in 2002. So, although trains have not stopped in Bulkington since the 1930s, they continue to influence our landscape.

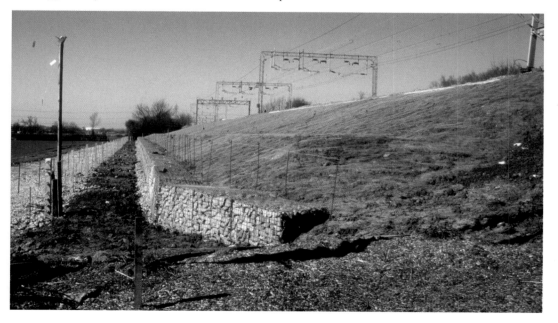

New Development

Above we see the old access to the railway station, inaccessible since metal fencing was installed. The beautiful lavatera used to be a delight from the road and helped to shield the view of the timber merchant. In its place is the housing development called Weavers Close, which has an interesting mix of colour and design. The modern pressures of price and land shortages make this a high-density development for the twenty-first century.

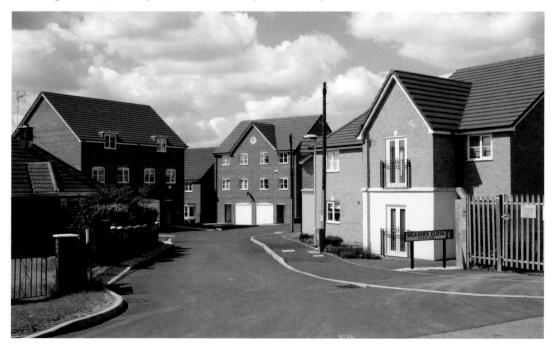

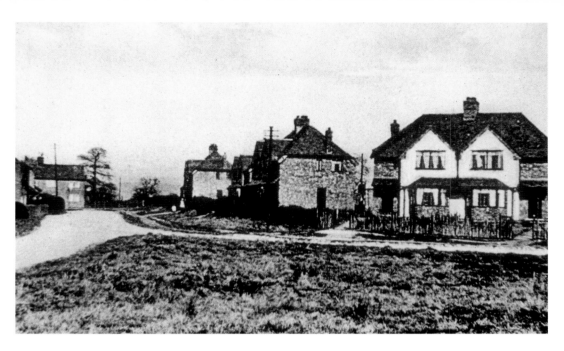

Pre-War Development

This part of Bulkington is known as the Bull Ring and the pictures show the early council housing in the village. Most were bought by their tenants when Margaret Thatcher made that possible. There is a contrast between the generous space and land accorded to early council housing in the 1920s and the constraints on modern builders and purchasers.

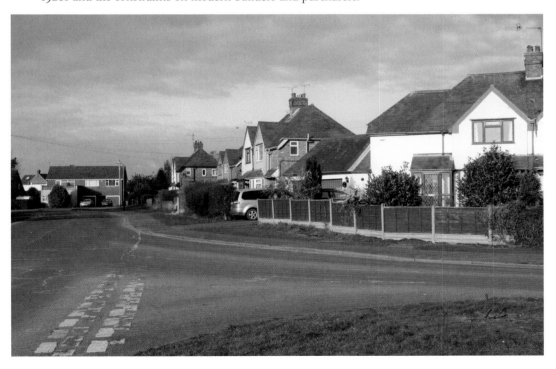

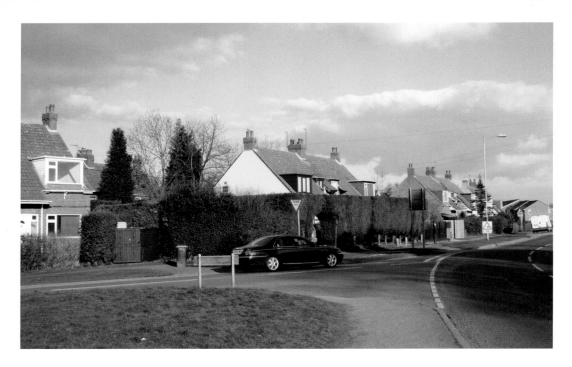

The Bull Ring

When council housing started in the late 1920s the new houses were very different from the tiny houses that crowded on top of each other in Church Street or Ryton. The new development was between the edge of the old village and the outlying community at Weston-in-Arden. The houses had gardens and space. Ordinary housing today does not have that distinction.

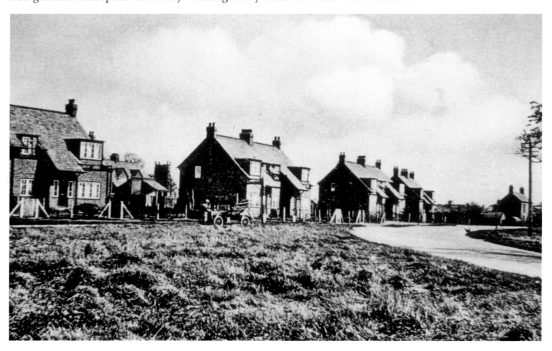

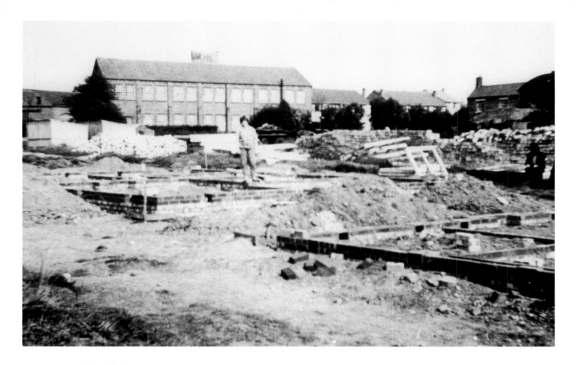

An Industrial Past

On our walk through the village we see few reminders of an industrial past, though the photographs show where it once existed. The picture above shows the large Victoria Cotton Mills. Like similar factories in Nuneaton, it opened after the ribbon-weaving industry declined. Above the roof is the top of the water tower, and the footings are those of houses and bungalows in Leyland Road. Phillip Docker Court is now on the site of the factory.

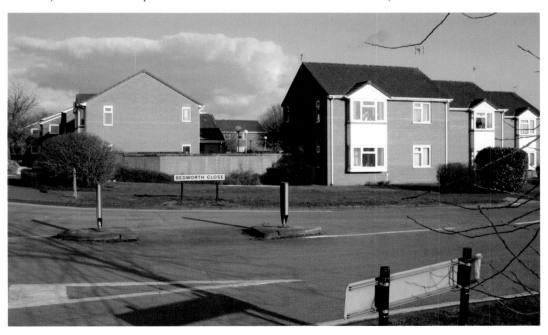

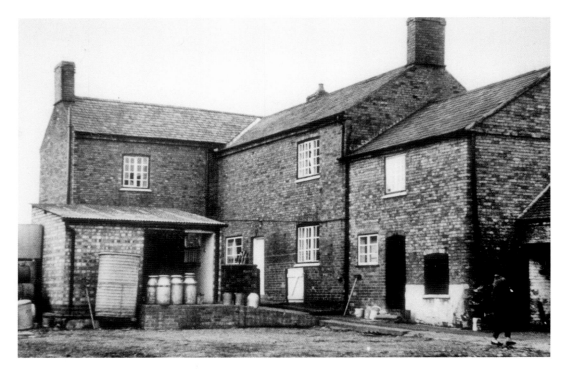

A Farming Past

Home Farm was run by the Record family for generations. It stood on the road from Bedworth (renamed Bedworth Close when the new road was built to bypass the village), a typical post-enclosure farmhouse. Many photographs of the village came via May Record, who married John Dawkins. They built 'Jordan Well', their family house, on Record farmland in Coventry Road. The colour picture shows some of the estate built on the farm site.

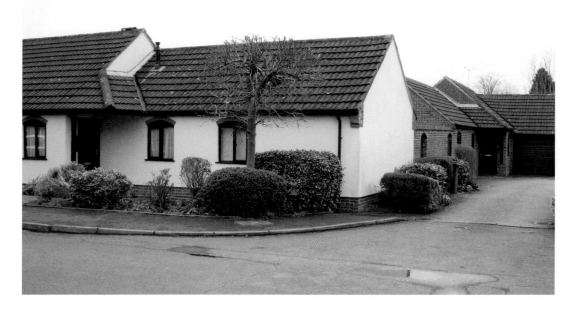

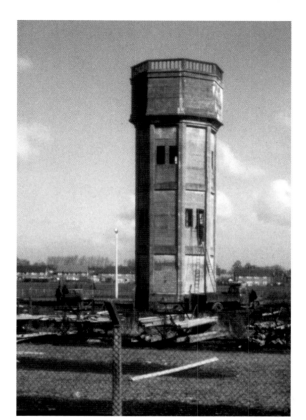

Forgotten Landmark

The water tower was built on the highest spot for miles around. It stood where the new road passes in front of Phillip Docker Court and was built in 1927. Look closely and you will see a man on a tall ladder with its base on a lorry. Who mentioned health and safety? The picture below shows a typical village shop. It stood opposite Home Farm and was only a short distance from the water tower.

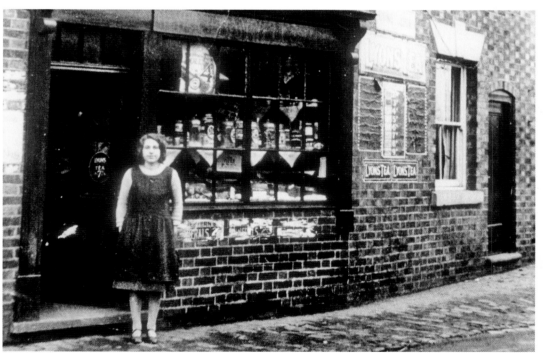

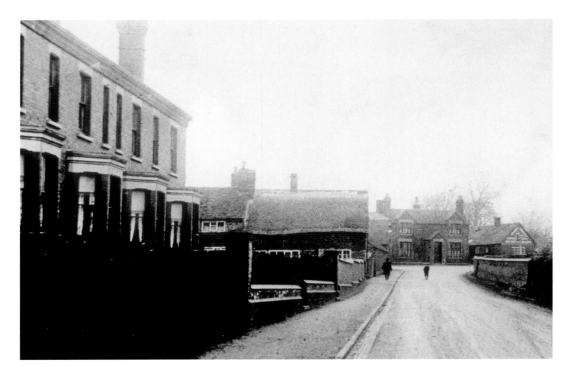

Coventry Road

From Bedworth Close we turn right into Coventry Road, a popular residential area with open views (for the moment) across farmland. The houses on the left still stand well. The colour picture was taken from the other side of the road to improve the composition, but you can still see many differences, especially in the distance. Land on the right side of the 1907 picture was used for allotments.

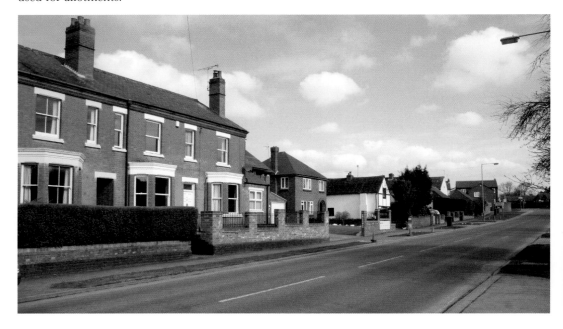

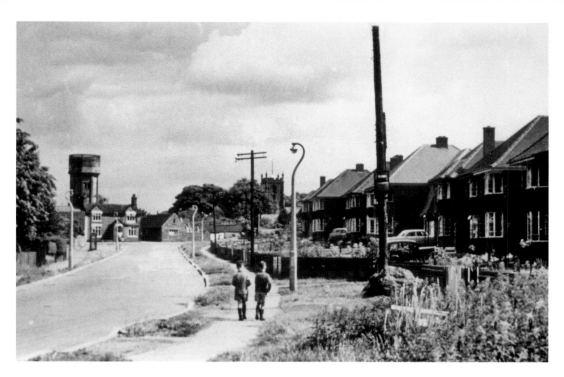

Coventry Road

These pictures were taken just a few yards down the road from those opposite, and on the other side of the road. The postcard is from the 1950s and shows some of the houses built on the old allotments. The water tower is clearly visible, as is the church tower. In the colour picture, taken on Good Friday 2013, the church tower is there but is hidden by trees.

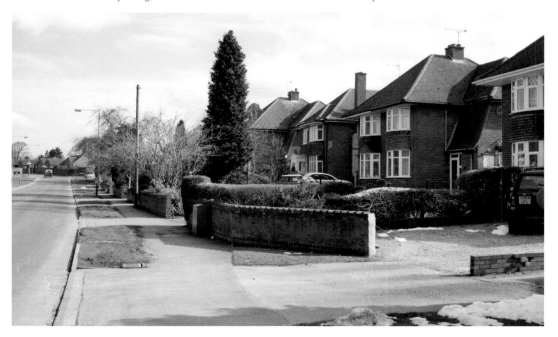

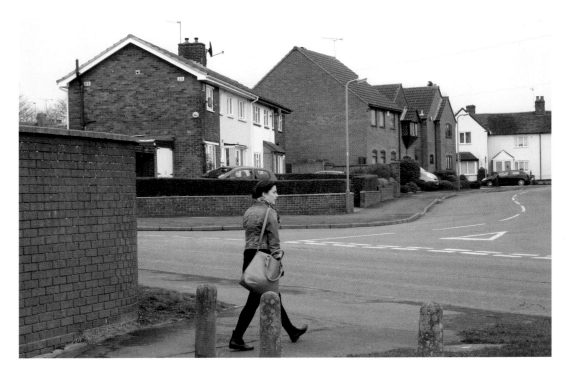

Ashleys House and Workshop

This was demolished when the new road was put through the village. It stood in line with the houses shown above. Ashleys had been established as builders and carpenters since 1830. The house had an imposing view down the Coventry Road when it was just a country lane. The top photograph was taken in Bedworth Close, formerly Bedworth Road, near the point where it became Chequer Street and meandered through the village as it had done for centuries.

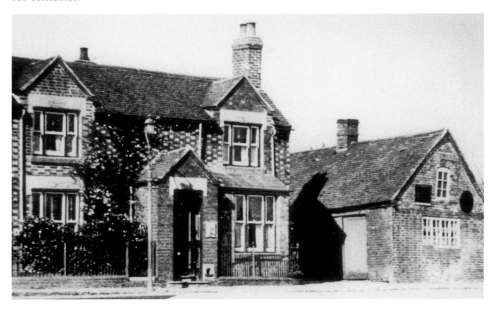

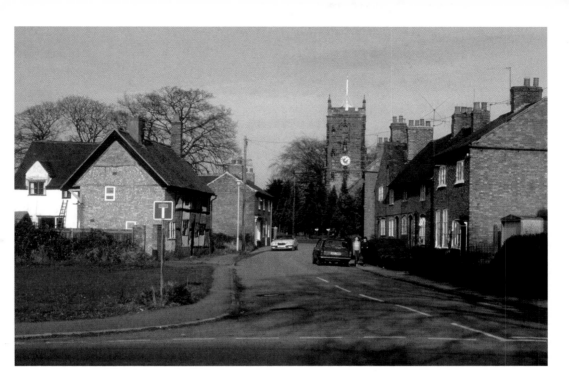

Church Street

This is the only part of Bulkington to show us how the village looked a century ago. The cars are a distraction but the top picture, taken around 1985, shows them as less intrusive thirty years ago. The Crown pub had been demolished by then but is visible in the 1905 picture. The large ground-floor windows show the ribbon-weaving history of the area. Originally the street led to the churchyard gates; now the main road intervenes.

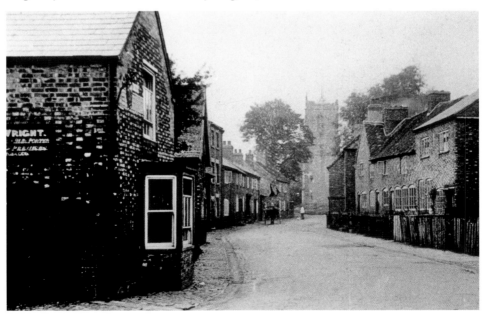

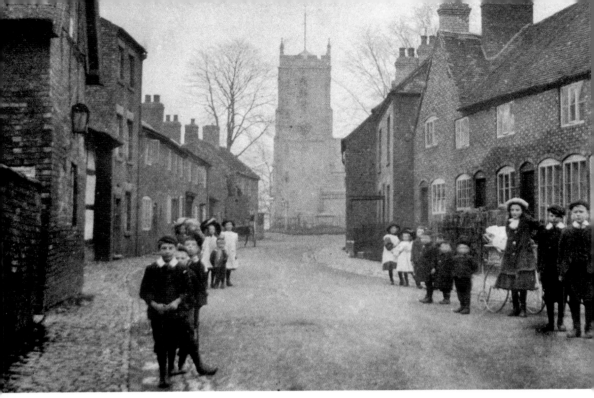

Church Street

This wonderful picture captured so much of life before 1910. The photographer has grouped the children, possibly in family clusters, but not to distract from the view of church. The paving is cobbled. On the left is a glimpse of the half-timbered white cottage that now dominates the street. This side of the cottage is another half-timbered thatched cottage, which was at the bottom of the yard of the Crown Inn. On the right, the cottages show adaptations made to an earlier building to enable weaving looms to operate. One of those is featured in the colour picture. It shows a lovely climbing rose which adds a picturesque flourish to the street during early summer.

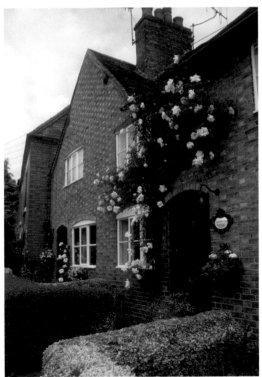

Church Street

It is still possible to find chocolate-box views in Bulkington but it is a challenge for the photographer. The light was right for me here; the roses in the foreground add colour and the leaves of the overhanging copper beech frame the picture. The copper beech was a truly magnificent specimen and much loved in the village, so it is a particular pleasure to be able to show it in the picture below. It was felled a few years ago when disease threatened to make it dangerous. It had been planted in the days when Villa Farm stood nearby.

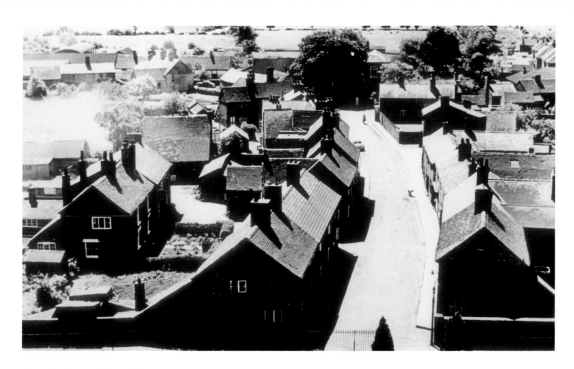

Church Street from Above

The top picture was taken in 1959 and shows Church Street and the village as it had been for a century or more. The colour picture from March 2013 shows the impact of the motor car as the new road separated Church Street from the church. Careful study shows many other changes, discernible even through the snow!

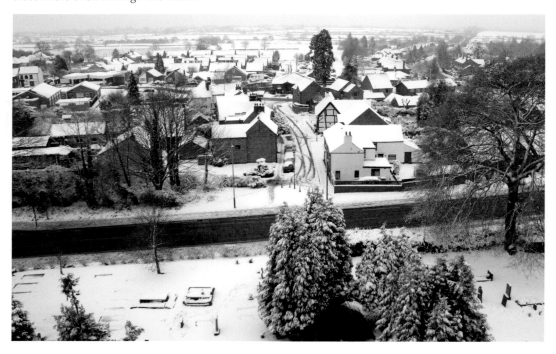

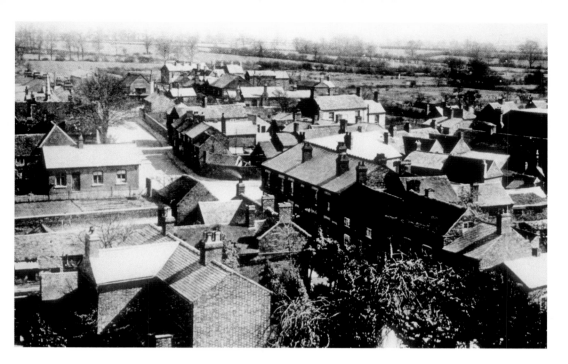

Village from the Church Tower
The top picture is a 1930s postcard view that shows the compact nature of the village. Focus on the White Lion in both views to help establish the changes over eighty years. The corner of School Road and Leicester Street, now a wide-open space, was once a cluster of houses and shops.

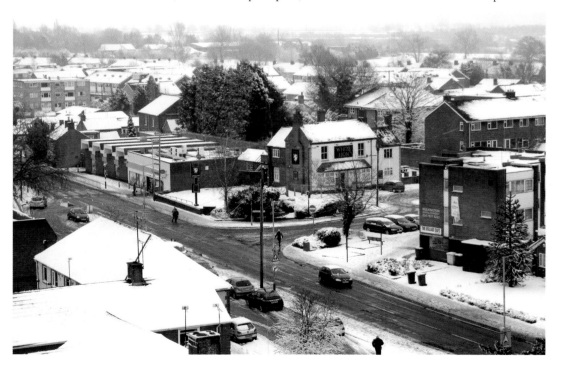

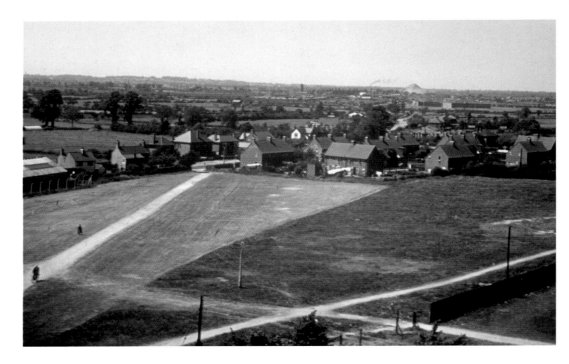

Recreation Ground from Church Tower

The top picture from 1959 shows the path to Bedworth Road, which is now the main road. In the distance is Bedworth water tower, the spoil heap from Newdegate colliery, and the recently built Nicholas Chamberlaine School. The March 2013 view shows improvements to the recreation ground, with its MUGA sports facilities and play area, bowling green and line of new trees alongside the path.

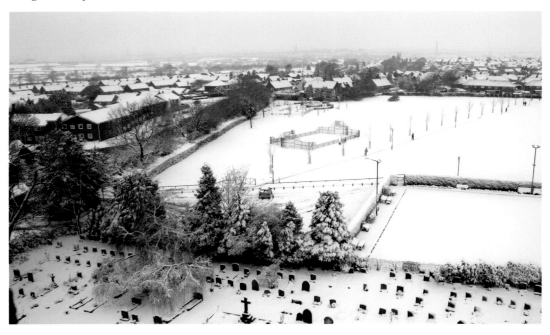

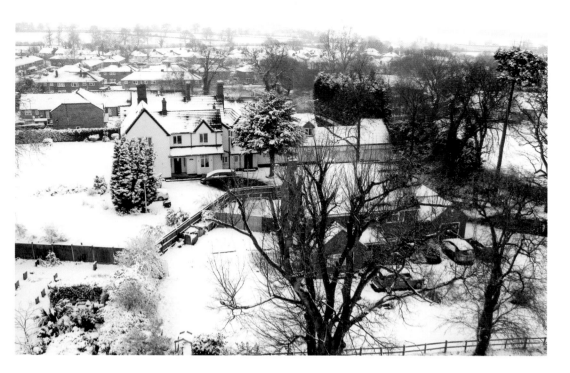

Vicarages

The top scene shows the original vicarage, which has been considerably extended in recent years. In the foreground is the new vicarage, with its own gateway into the churchyard. All the buildings in the background are part of Bulkington's post-war development. The picture of the original vicarage below is from a 1930s postcard.

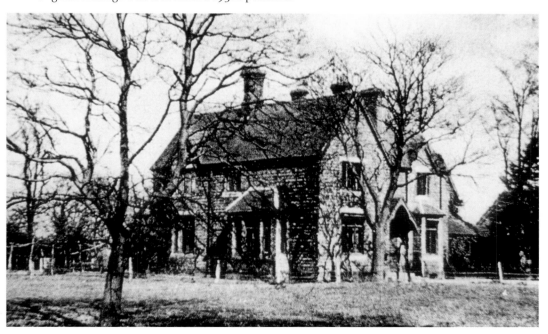

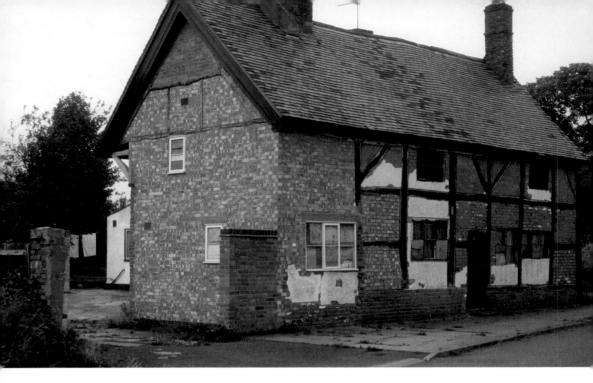

White House in Church Street

The top picture from 1980 shows how varied the history of a building can be. The end shows major reworking to what might well have been an earlier extension to the seventeenth-century building with connections to Ford's Hospital in Coventry. By 1980 the building was in a bad way, but the restoration gained a Bedworth Society Award.

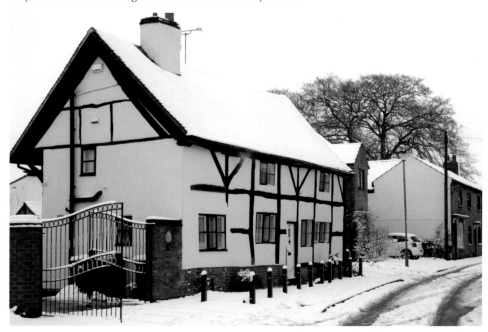

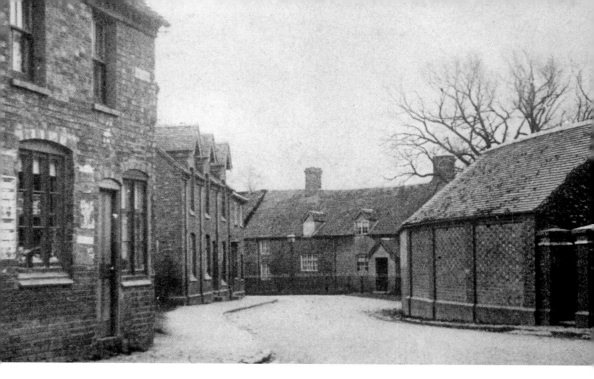

Chequer Street

All that remains of the 1907 view is the curve in the road. The line of little cottages on the left have all gone, replaced by the WMC car park, though there were plans for some housing here. The little shop was Hickinbottom's sweet shop. In the middle of the picture is The Poplars Farm, latterly run by Reg Green. Off the picture to the right was Villa Farm.

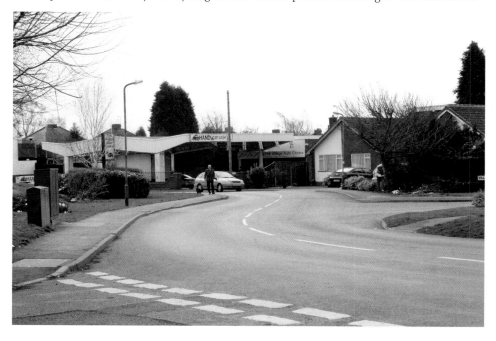

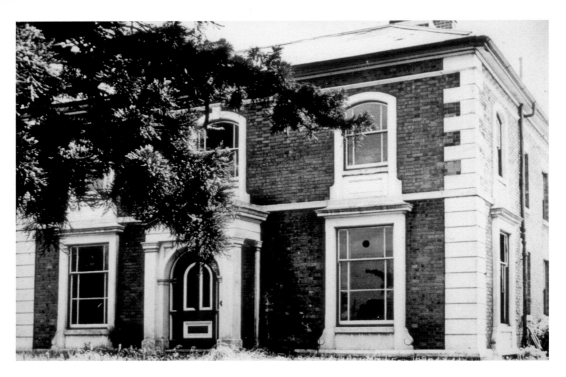

Villa Farm

This fine building used to look up Church Street. It was not a traditional farmhouse but was owned by Mr Dewis, one of the local wealthy men, an early car owner who ran the Victoria Mills. On the site in later years was Bulkington Clinic. Later it was adapted for use as sheltered accommodation. In the foreground of the lower picture is all that remains of the copper beech tree.

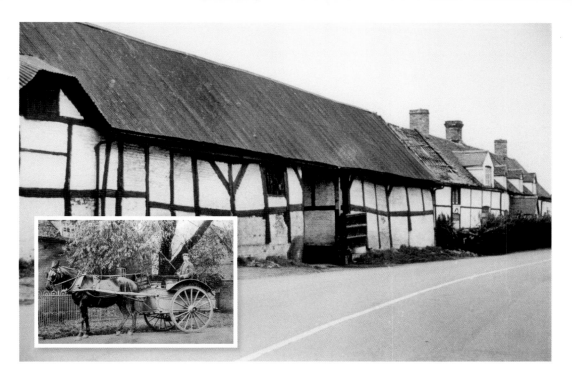

Chequer Street

The half-timbered barn should never have been demolished. It was a reminder of Bulkington's agricultural past from long before enclosure altered the shape of farming. In the distance is The Poplars Farm, and the inset shows James Evans, the tenant farmer there before 1910. Perhaps in future years we will regret the passing of the garage as we do the barn, but don't hold your breath.

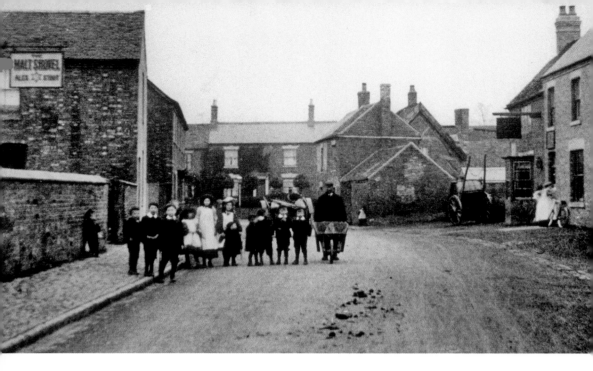

Chequer Street

Some of the buildings in the 1905 picture remain – notably the pub and its bow window. The publican in the doorway was Mr J. Smith and the man with the wheelbarrow and dog was Mr Pegg. The Malt Shovel has gone but Bulkington WMC is on the site. The buildings in the distance are still there, as the new picture shows.

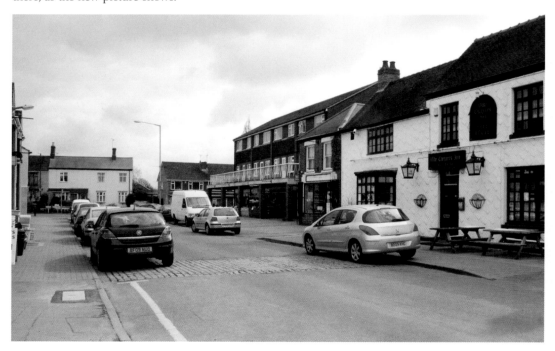

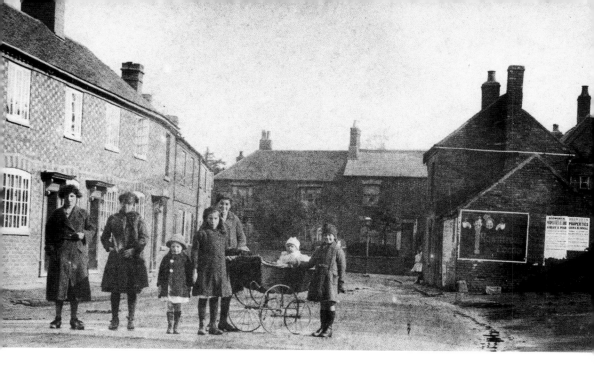

Chequer Street

A similar view to the one on page 28 but around twenty years later, looking towards the buildings on the south side of the street, some of which remain. Those on the extreme left with the chequered brick have gone; they were ribbon weavers' cottages with large, north-facing windows behind which were their hand looms. The advertisement is for Rowntree's chocolate. It was quite safe for the children to straddle the road for the photograph. Nowadays one risks injury from speeding or badly parked cars!

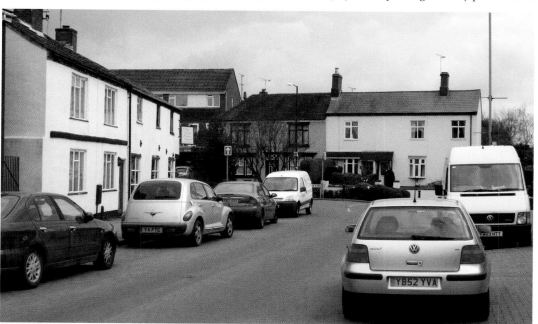

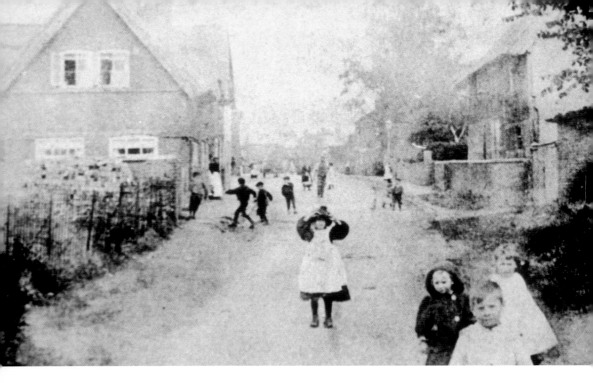

Barnacle Lane and Chequer Street

The above picture is one of my favourites. It is indistinct and faded but it encapsulates village life in the early 1900s. It was taken a few yards down Barnacle Lane. On the right is a farm. The children from nearby houses play in the street, but are easily summoned home. The modern equivalent would be too depressing, so I have moved up a few yards and looked half left to the old buildings on the corner of Chequer Street, shown in the early 1990s.

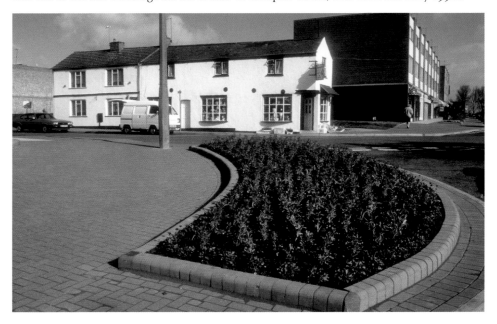

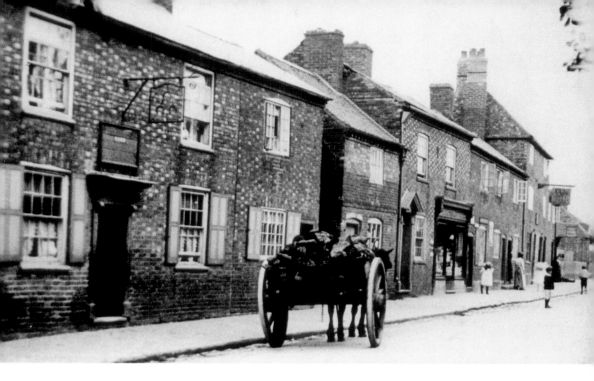

Leicester Street

Old Leicester Street was wide, but not as wide as now. In the 1990s the tarmac was softened with flower beds and trees, which is good but cannot disguise the mediocrity of the new architecture, which insults the village. The 1905 view shows a typical mix of homes, small shops and pubs – there were three on this side of the street. I have tried to soften the modern view with the tree, but it is grim.

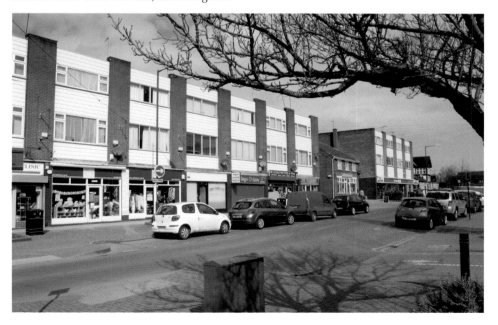

Village Square and Leicester Street

In 1988 the 1911 crowd scene helped to prove that space in front of the White Lion was public space and should not be enclosed. The top picture shows how the pub had implanted telegraph poles to stop cars from parking. It provoked an outcry. Eventually wisdom prevailed and the posts were removed. Now the County Council has imposed a one-way system; however, this does not prevent people driving the wrong way to the White Lion car park! The top picture shows the insensitivity of the local authority in placing a recycling container in the centre of the village street. Once again, wisdom prevailed and it was relocated to a more discreet place.

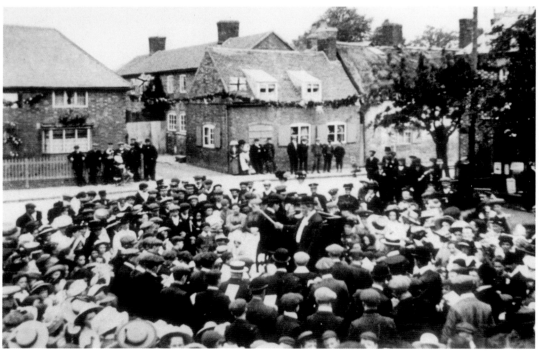

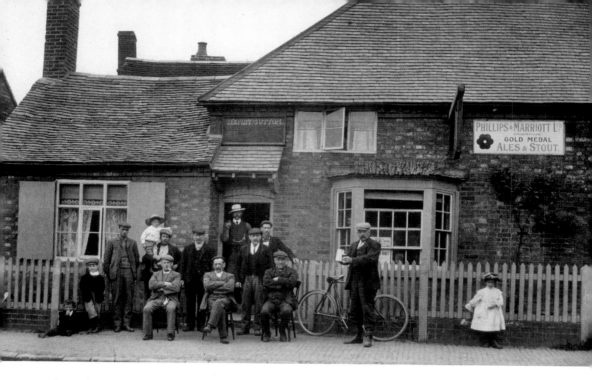

The Rule & Compass, Leicester Street

The top picture shows the old Rule & Compass before the Great War. The men have clearly been instructed to sit outside for the photograph. The folded arms suggest an unwilling compliance! Henry Sutton was the publican – perhaps he is the man in the doorway. The modern picture shows people in front of the newer pub waiting for the carnival procession. The two pictures show how fashion has changed over a century.

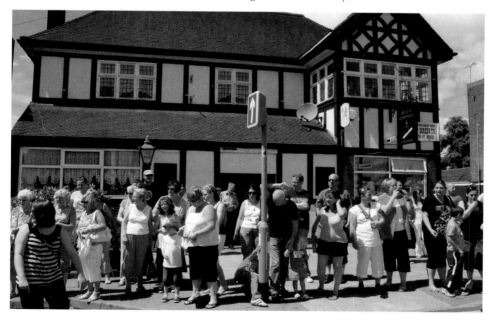

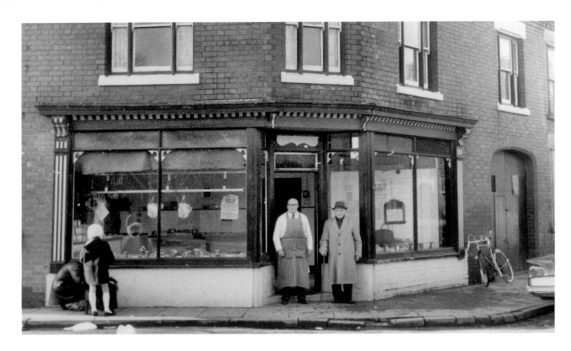

Corner of Leicester Street and School Road

The 1966 view shows the corner shop, latterly used by Furborough the butcher. The new corner is attractive when the floral displays are at their best, but the days of wonderful displays have gone. The lovely lithograph was given away in 1899 as a calendar to customers of the same corner shop when it was used by James Wilson, a grocer and baker.

A Basket of Flowers

For a decade the basket of flowers featured here. It is a village symbol, appears on signs and inspired a poem – 'The Bulkington Anthem'.

I've been out gathering flowers
Out in the bright sunshine
Passing away happy hours
With an old sweetheart of mine
Take them from me as a token
I lay them down at your feet
Don't let our friendship be broken
Accept all these flowers so sweet.

There are roses and lilies, violets blue
Snowdrops and pansies
Bright primroses too
Sweet Williams and fuchsia
Sweetheart for you
In my neat little basket of flowers.

Though the road be one ray of sunshine
As onward through life we must go
Praying that nothing should part us
Nor death separate us two.
Though the road be one ray of sunshine
As the flowers we pluck so sweet
Don't let our friendship be broken
I lay them down at your feet.

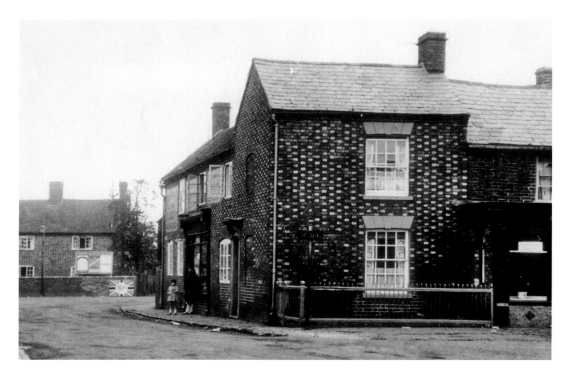

Bicknell's Corner

No need for a modern version, though you can see it from the church tower on page 21. It is now empty space and bushes. These two pictures show how there was once a cluster of property facing School Road and Leicester Street. The lower picture here was to the right of the property shown above, and at the time it was taken, around 1905, the shop was the post office. The top picture is about twenty-five years later.

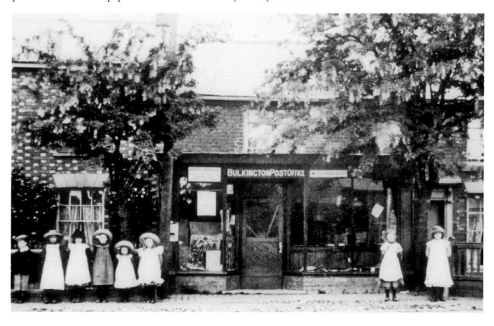

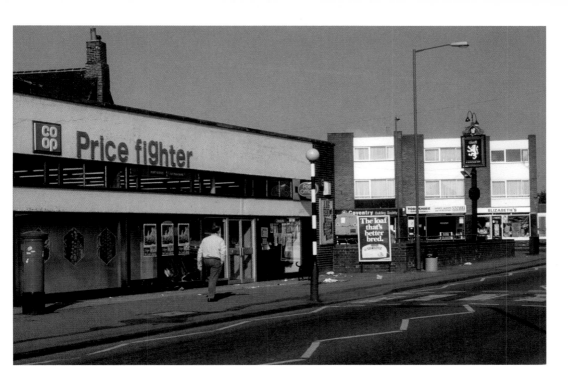

School Road

At a superficial glance we recognise this view above instantly. A closer look shows that in twenty-five years all three shops on the right have changed hands, and the Co-op is into its third makeover. One wonders how many of the letters were in place before the sign man realised he was going to have a problem with the 'g'. The picture below shows a little glimpse of nineteenth-century Bulkington around the Congregational church.

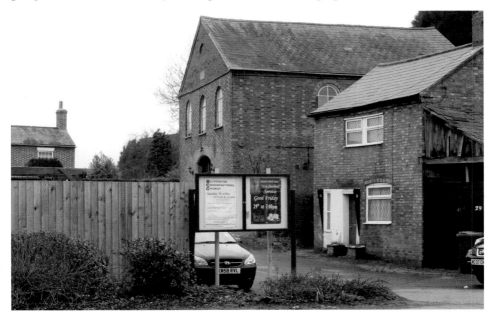

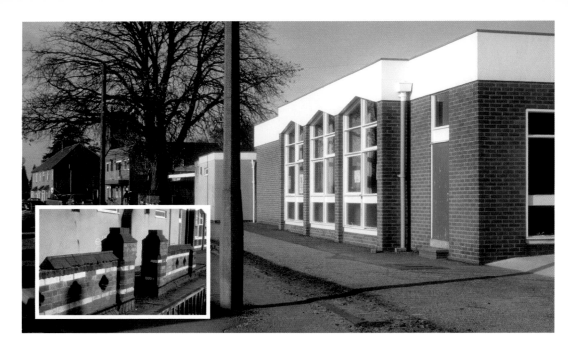

School

These pictures show changes to school buildings. The school was an impressive building when it opened in 1862, soon after the ribbon trade collapsed and there were eighty-three empty houses. Thomas Winterton was an able headteacher and the school prospered. A new junior school was built in 1959. The old one, adapted as a parish community centre, then became a car salesroom. For years a bit of school wall survived (*inset*) as a reminder of the past.

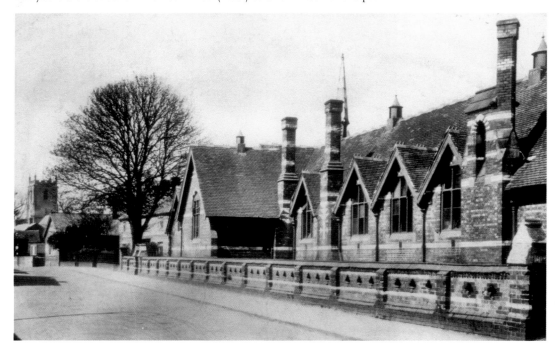

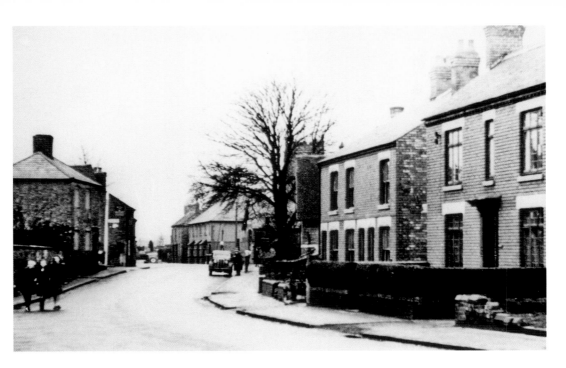

School Road

The buildings on the right remain recognisable but the new road removed the bend in the road. The present slip road in front of the library was the old road. Most of the left side has been completely rebuilt since the top picture was taken in the 1950s.

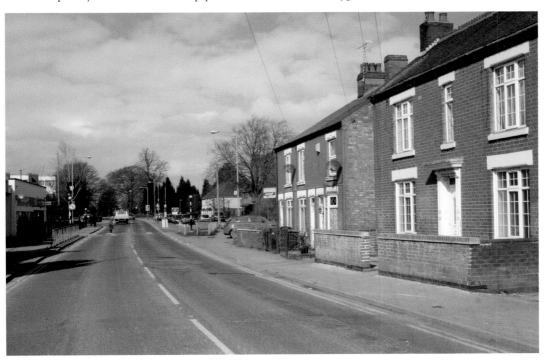

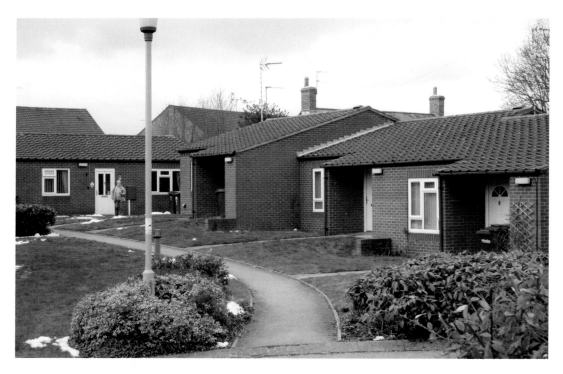

The Sandpits

This part of Bulkington has changed beyond recognition. The old picture dates from 1907 and shows allotments and the typical large windows of the ribbon weavers' homes. The modern picture shows the land now used as a complex of old people's bungalows.

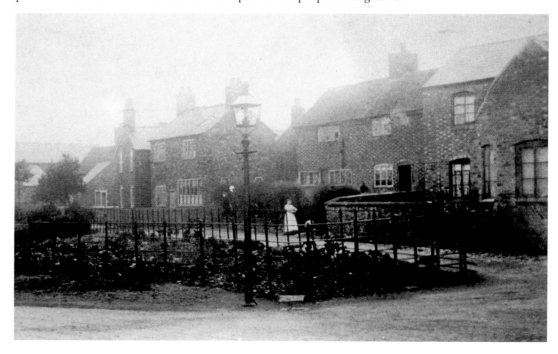

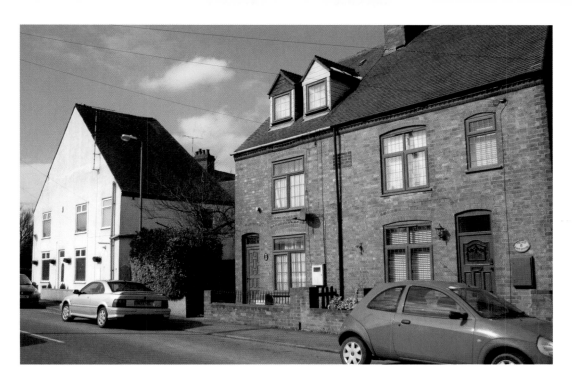

Arden Road

The older 1910 picture shows very old cottages on the left-hand side. They did not survive. They were much older than the ones on the right, which date from the turn of the century. The right-hand house also served as the post office after it moved from Leicester Street. Before New Road was built this was the Nuneaton Road and Ryton was still a clearly distinct village.

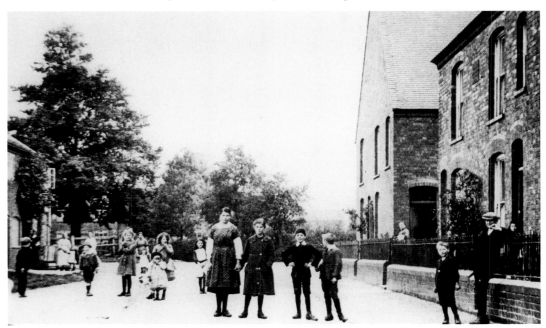

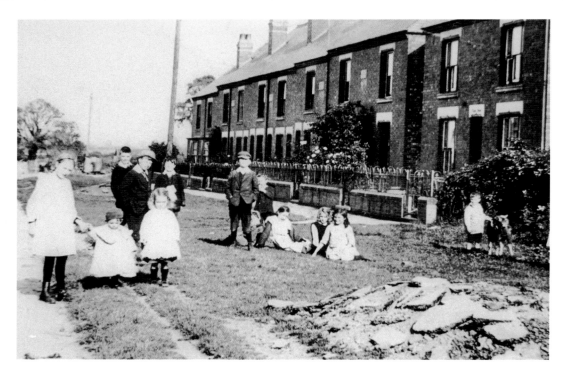

Arden Road

Looking towards Nuneaton Road, all these houses were built between 1900 and 1915 and replaced older cottages. At the back of The Homestead, the first house on the right in both pictures was a ribbon-weaving workshop, probably the last working workshop in the village. It has now been demolished but some photographs survive.

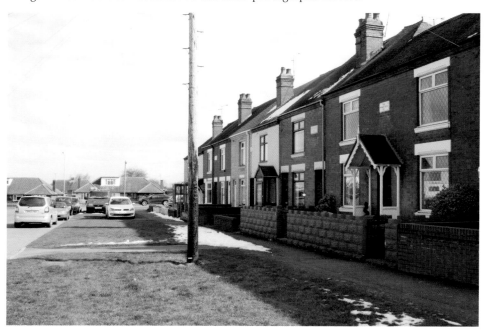

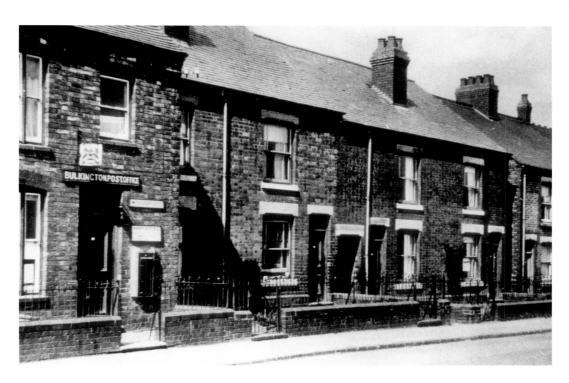

Arden Road

The top picture from the 1930s shows when the post office was in Arden Road. The lower picture shows the corner of Arden Road looking towards Nuneaton in the 1950s. The shop is still an off-licence, although much altered. Nuneaton Road is an example of 1930s ribbon development on the left-hand side, and post-war estates on the right.

New Road

New Road is just that! A hundred years ago it was open fields and allotments separating Bulkington from Ryton. The picture from the 1930s shows what looks like a model estate – neat hedges of uniform height, young trees, no street signs and no traffic. The bus stop is still in the same position!

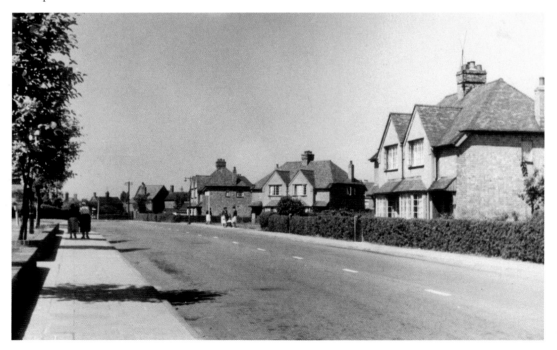

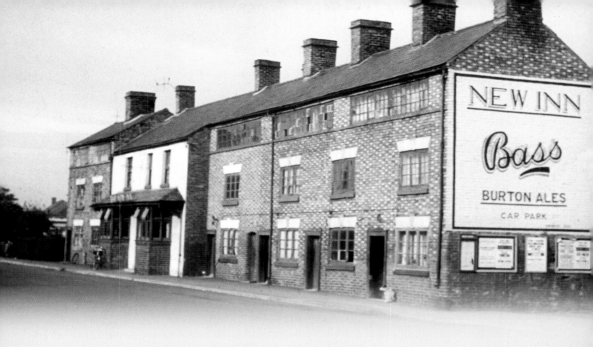

CHAPTER 2

Ryton

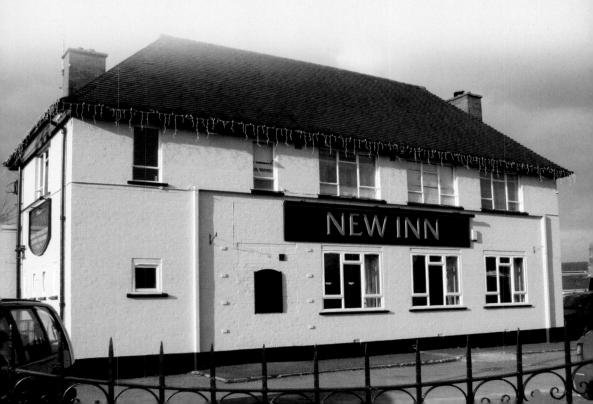

Approach to Ryton

The previous page shows the old line of property with its ribbon weavers' top shops, and the New Inn painted white. Underneath is the newer New Inn. On this page is the junction of Wolvey Road and Rugby Road. In the middle is the old forge, though no longer in use as such. The bottom picture from March 2013 shows some old property in Wolvey Road, but the rest has been rebuilt in recent years.

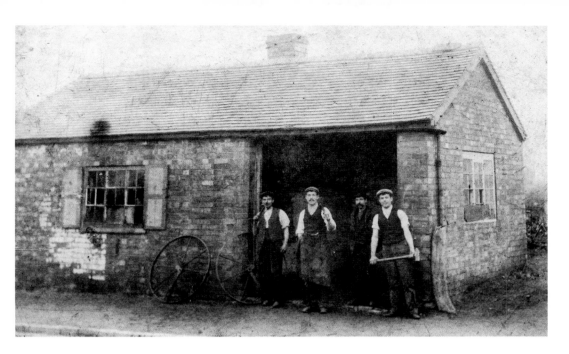

Impact on Our Landscape

One picture shows the Ryton forge early last century. The motor car has had a massive impact on all our lives, and on the appearance of places, but for centuries horses were our means of transport and blacksmiths ran forges in every community. The picture below from 1988 shows a Second World War pillbox on Wolvey Road to defend Bramcote against enemy invasion. Many remain, virtually indestructible but too much bother to remove.

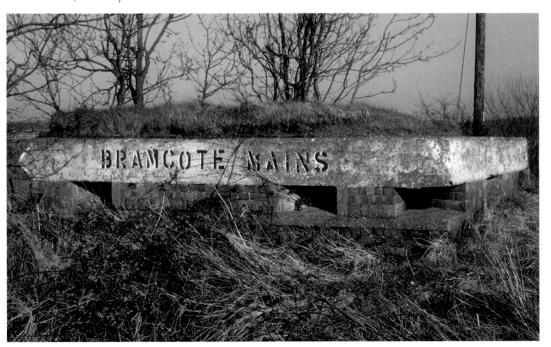

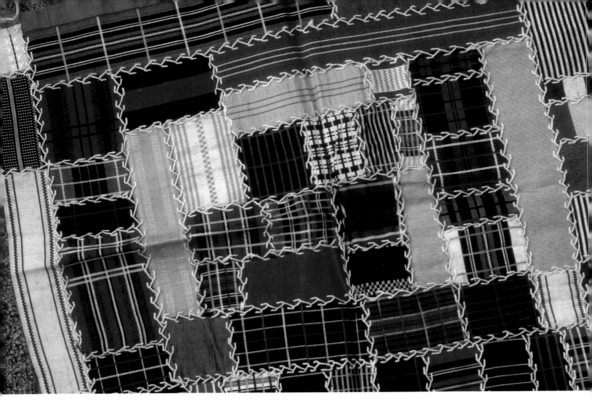

Ribbon Weaving

Traditionally Bulkington was a farming community, but in common with local towns and villages it changed dramatically into a silk ribbon-weaving area, starting in the eighteenth century and expanding rapidly in the nineteenth century, so that by 1851 half the population worked either directly as weavers or in linked trades for the largely cottage industry, where a family worked its own loom. In villages most weaving was on hand looms. In bigger towns like Nuneaton, Bedworth and Coventry the cottage industry became factory based, with large Jacquard looms, all of which made life hard for Bulkington hand loom weavers. The industry collapsed in 1860 and the village suffered abject poverty. Many left the area. Ryton grew up almost exclusively as a weaving district and though the industry has gone the pub remains. All the ribbons in the picture were woven in Bulkington or Ryton.

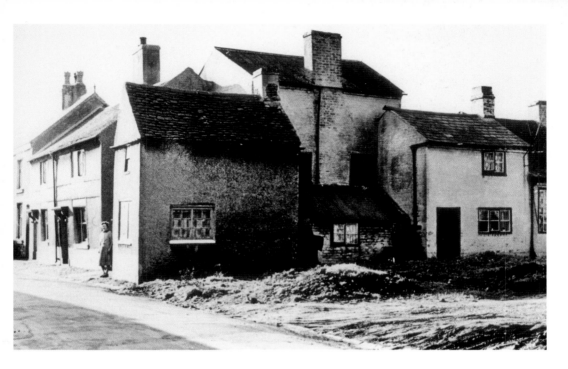

Long Street, Ryton

The top picture shows the way in which Ryton piled buildings one against the other to accommodate extra work space. On the very edge to the left is the only part of this group that remains, now a lovely detached house. It is shown below but my shot is taken from the other end looking up Long Street and illustrating how all but two or three of the weaving cottages and workshops have disappeared.

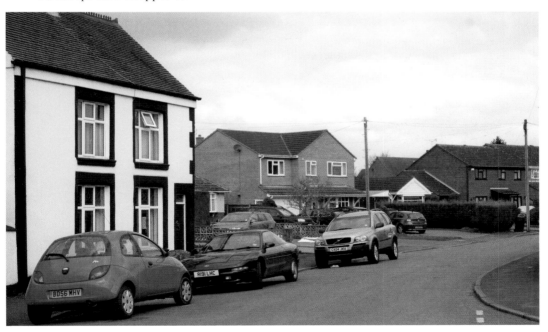

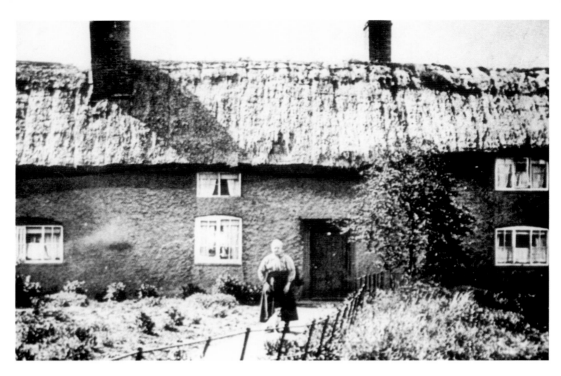

Farm Buildings at Ryton

Farming predated weaving at Ryton, and continued after its demise. The picture here shows a line of farm cottages in Long Street when they were still thatched, though in need of repair. By 1961 the thatch was replaced with corrugated iron and it became a farm run by Mrs Bayliss.

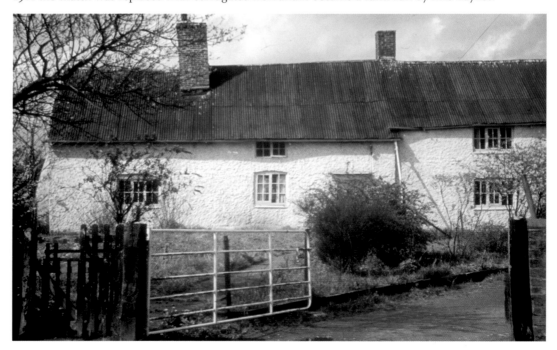

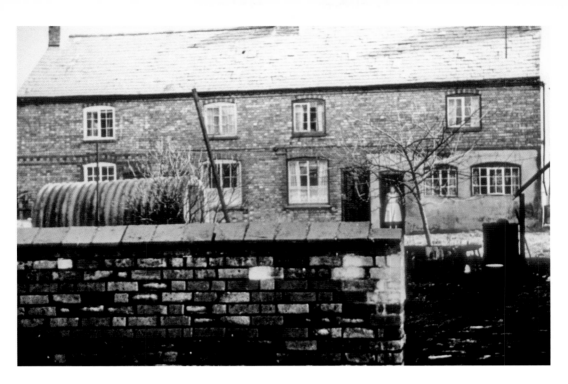

Long Street

Some lines of cottages were at right angles to the road. These show larger ground-floor windows giving light for the looms. Also in evidence in this 1957 photograph is the wartime Anderson shelter in the garden. The bottom picture shows the effect of a gas leak and explosion on Elson's house on 21 January 1956. The houses next to it remain and in the distance are the houses shown on page 49, almost opposite the pub.

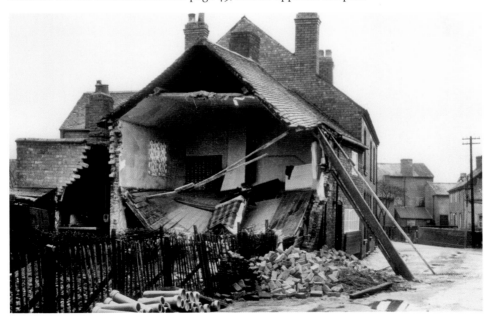

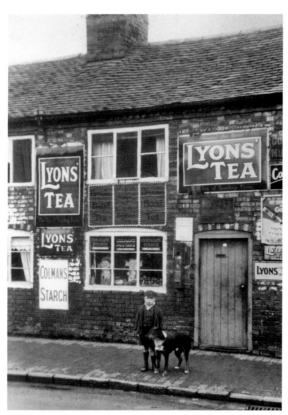

Little Shop at Ryton

This wonderful photograph tells such history. It was a little shop, possibly run by a widow trying to scrape a living from sales to neighbours in what is clearly a converted front room. Notice the condition of the door and the enamel advertising sign for Lyons' Tea. The little boy in his school cap with his dog poses patiently. It was in a line of cottages that stood somewhere near the entrance to Oakham Crescent.

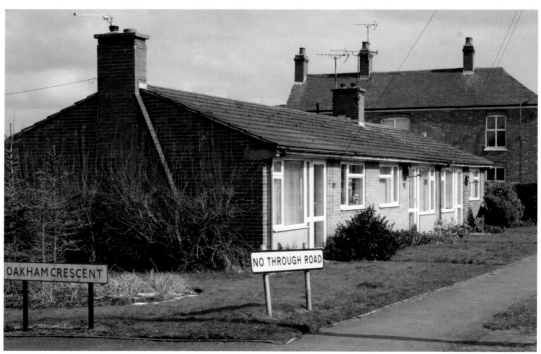

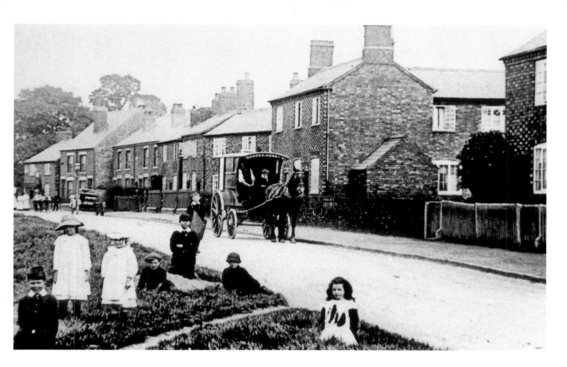

Wolvey Road, Ryton

This picture shows a very recognisable line of cottages. Closer inspection reveals some infilling and rebuilding, but the wide verge remains and Weaver's Cottage has a prominent position. The horse-drawn delivery vehicle is from Nuneaton and the children would have been thrilled to pick up a copy of this picture as a postcard a few days later in 1905 for a penny!

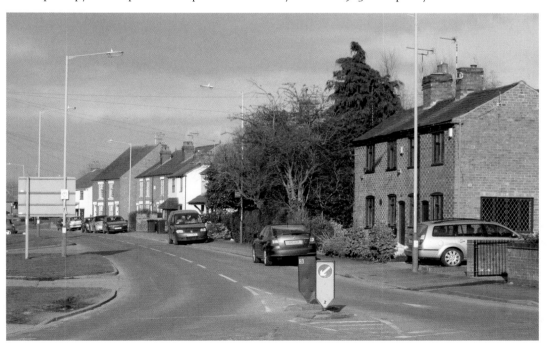

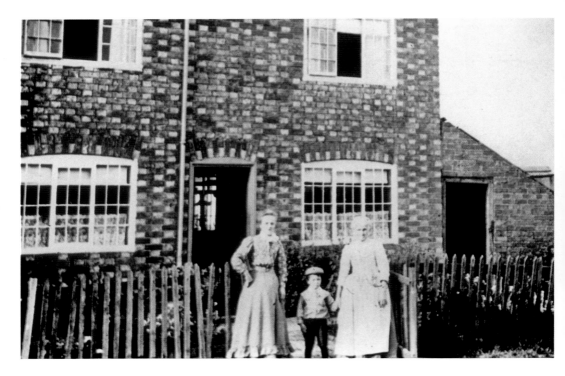

Weaver's Cottage

The last cottage on the road to Wolvey was lived in by a weaver, the older lady on the right, named Miss Cross. Look carefully through the open door and you can see her loom against the silhouette of the north-facing window at the rear of the house. The door has moved position but the cottage remains as a reminder of Bulkington's past.

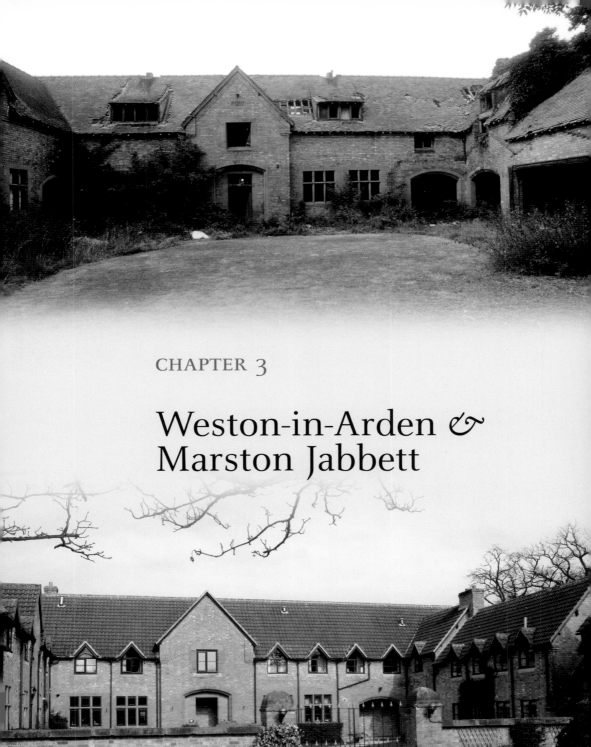

CHAPTER 3

Weston-in-Arden &
Marston Jabbett

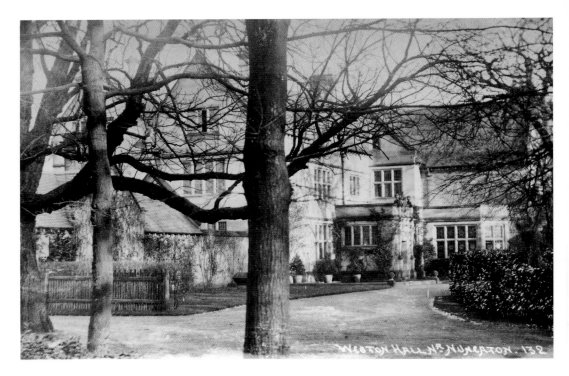

Weston Hall

The present Weston Hall is Elizabethan. The Purefoy and Hayward families had links to it. Richard Hayward, a gifted sculptor, made the font in church. Later, the Debarry family lived there and built the Catholic church opposite. In the 1870s it was bought by the Newdegates, and in 1928 Colonel Leyland acquired the estate. The pictures on page 55 show the derelict stable block in 1980 and now. This page shows views of the hall.

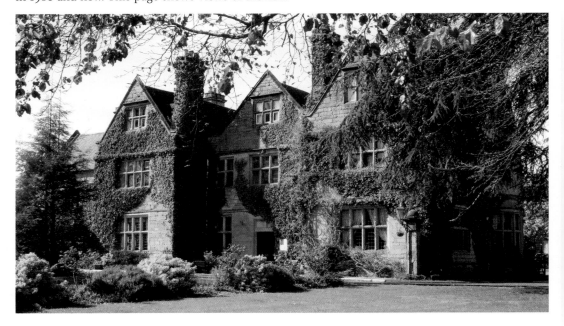

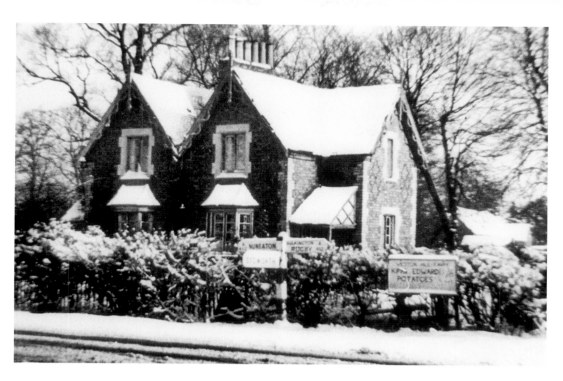

Weston Hill
The two houses in the snow, taken in the 1950s, have great charm. They stood opposite the end of Weston Lane, by the entrance to Weston Hill Farm. The modern house, also shown in the snow, is a fine building but it seems sad that the original one was not retained.

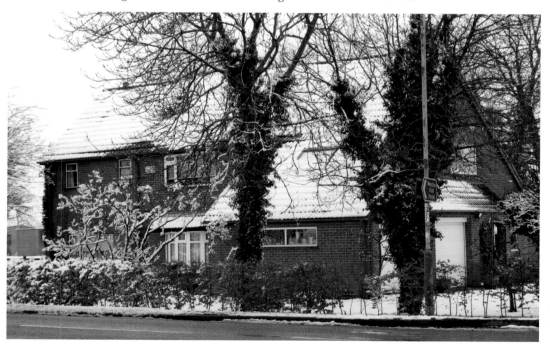

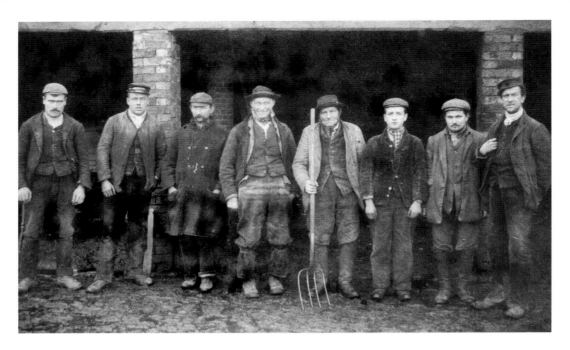

Weston Hill Farm

The picture shows workers on Warner's Farm at Weston Hill. The man with the fork is William Rollaston, a shepherd. Below, three generations of the Farndon family took a minute off from lambing on Easter Sunday 2013 to stand in the same spot. Arthur Farndon's grandfather, Alfred, came to the farm in 1926. His son Arthur also ran the last bakery in the village. Arthur's son, also Arthur, is shown here with son George and grandson Charlie.

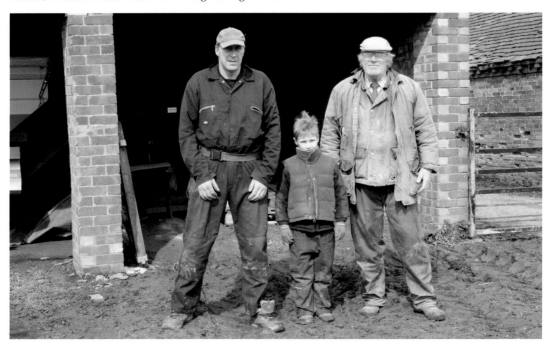

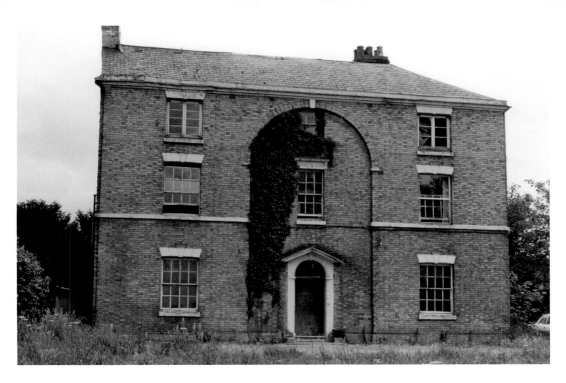

Marston Jabbett

An earlier Marston Hall was the birthplace of William Perkins, an influential Elizabethan Puritan divine. This hall was home to Richard and Elizabeth Johnson (buried at Bulkington), and she is immortalised as Sophy Pullet in George Eliot's *The Mill on the Floss*. The young Mary Ann Evans visited her relations and possibly walked the fields and flooded quarries nearby. The cottage here might have influenced her descriptions in *Silas Marner*.

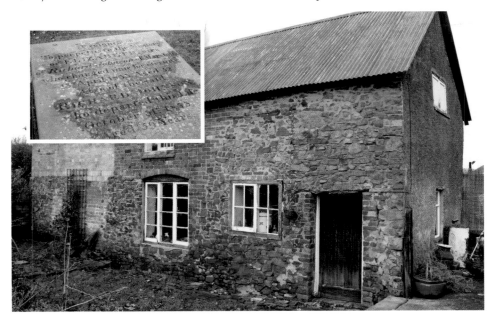

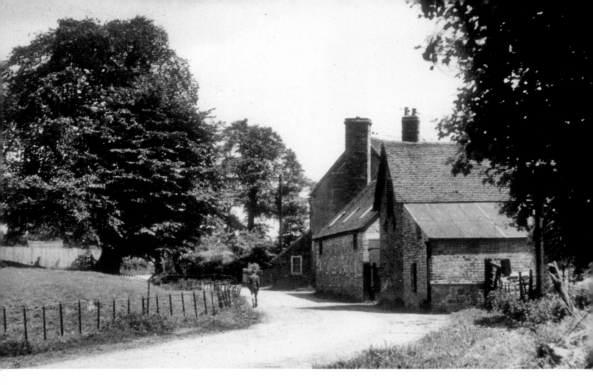

Marston Jabbett

The top picture shows a tranquil summer day in an English hamlet in the 1950s, with lovely trees, farm buildings and a schoolboy walking along the lane. The March 2013 view shows much the same buildings but the magnificent trees have gone, there are ugly pylons and posts, and walking on the road is now a hazardous occupation.

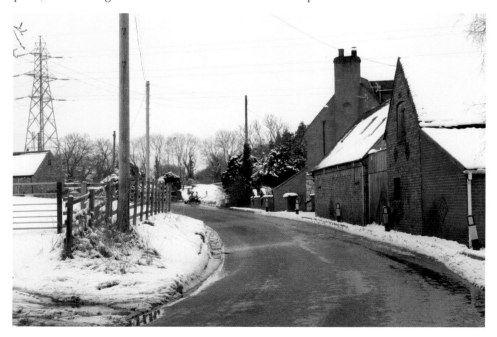

Yew Tree Cottage

The top picture was taken in the 1980s, and it always seemed a shame to see a perfectly good house looking empty and desolate, as this one did for many years. It was a great pleasure to see it restored and in use again as a family home, bringing more people to live in the hamlet of Marston Jabbett.

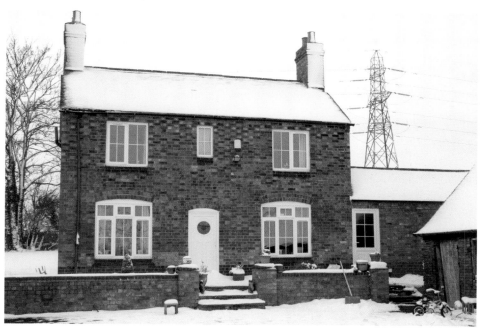

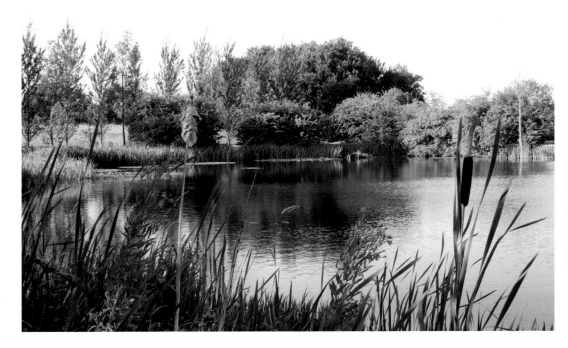

Impact on the Landscape

Every area shows evidence of earlier land use. The top picture shows the calm beauty of a flooded quarry at Marston Jabbett. Between here and Attleborough many quarries provided stone for local buildings. Most are filled in or flooded. This one was flooded by the early 1800s. The lower picture shows how medieval man shaped his landscape, especially in the Midlands, with ridge and furrow as part of the open-field method of farming.

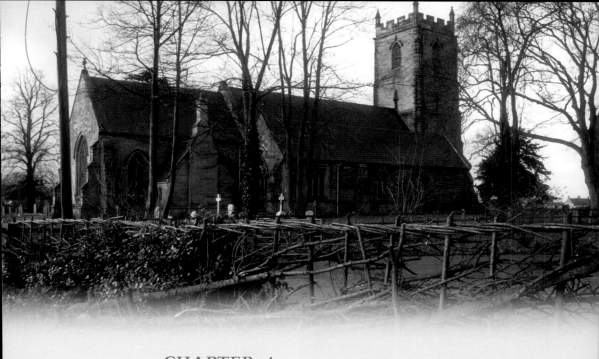

CHAPTER 4

Church & School

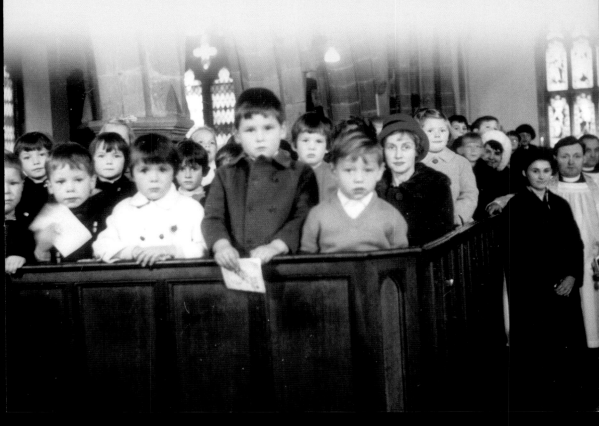

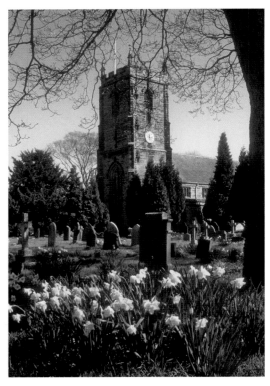

Parish Church of St James

The parish church occupies the highest ground for miles around and is a lovely building, packed with the history of parish residents. Page 63 shows the north side of the church, and includes some good hedging, along with a 1960s picture of children packed into the box pews, which lasted longer than in most churches. On this page are a picture of the church in spring and an interior view of the altar during one of many successful flower festivals. Much of the church dates from the thirteenth to the fifteenth centuries, but a major restoration in the 1860s altered the appearance considerably, raising the nave and chancel roofs. It is a huge task to keep wonderful church buildings in good repair, while also adapting them to modern living and modern worship without compromising the integrity of the original building. The present guardians of this church are doing a great job of creating usable spaces and keeping the building at the centre of village life.

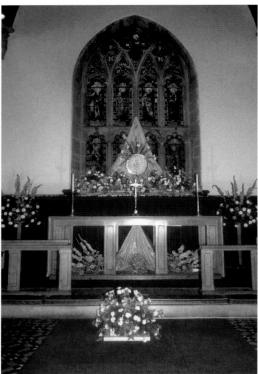

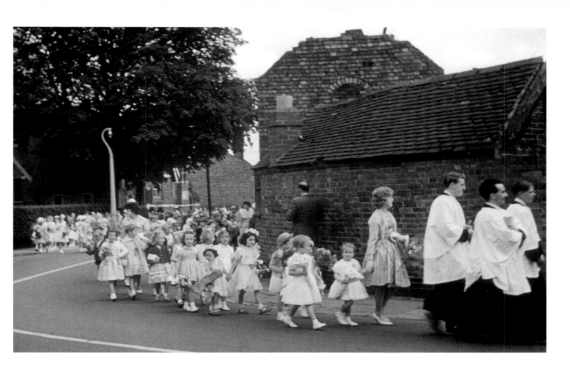

Sermons Sunday

Seen here are pictures from 1960 and 1962. For many of us that seems like the day before yesterday, but fifty years have seen huge changes. Large church-based activities still happened then; now they have all but disappeared. The top picture shows children processing from School Road into Leicester Street. The buildings have gone, the tree has gone and the children are nearly pensioners! The second picture shows children arriving at church in their Sunday best.

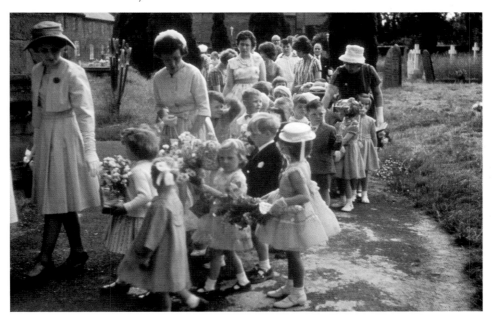

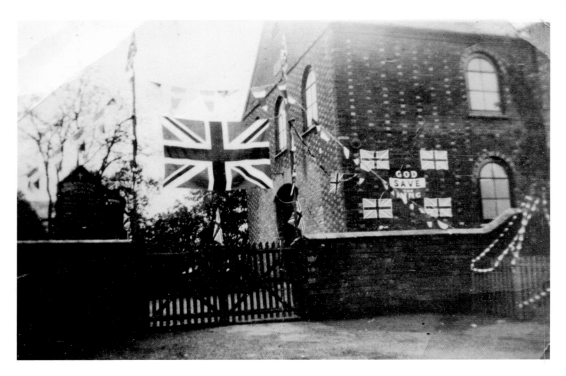

Bulkington Congregational Church

The top picture shows the church decorated for the Silver Jubilee of George V in 1935. Bulkington resisted union and the URC in 1972, but in 2011 celebrated its 200th anniversary in the village. The picture shows the special celebration service, which was followed by a superb tea in the Village Centre. One William Smith wrote moving comments about his early preaching at Bulkington in the 1850s after putting his dissolute early life behind him.

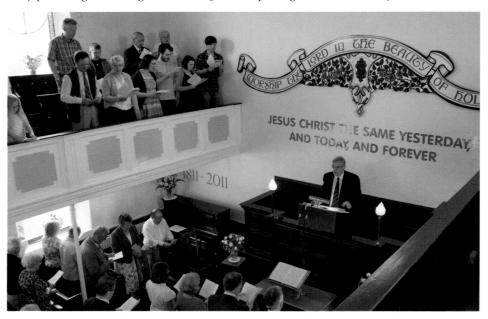

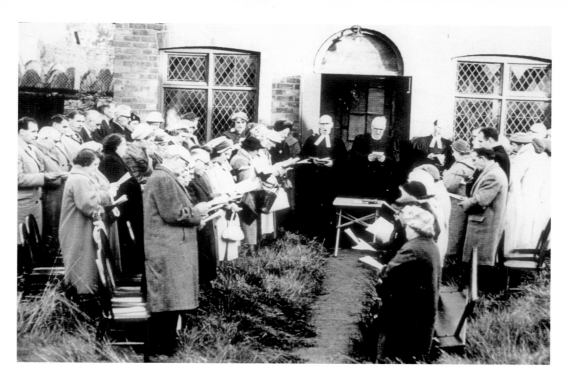

Primitive Methodists and Roman Catholics

There was a Primitive Methodist chapel off Bedworth Road, where Phillip Docker Court is now. It lasted for 110 years but became unsafe, and their final service, shown here on 12 October 1960, was held outdoors. But that would not have bothered Wesley. The Catholic church at Weston was built by Richard Debarry of Weston Hall in 1869. It is a delight, shown here surrounded by cherry blossom.

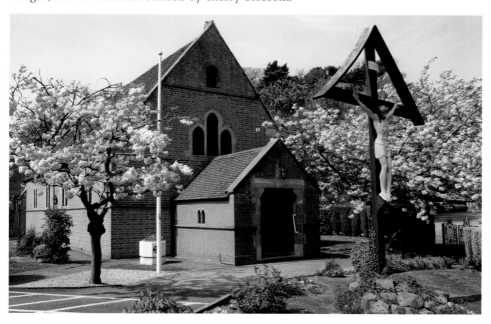

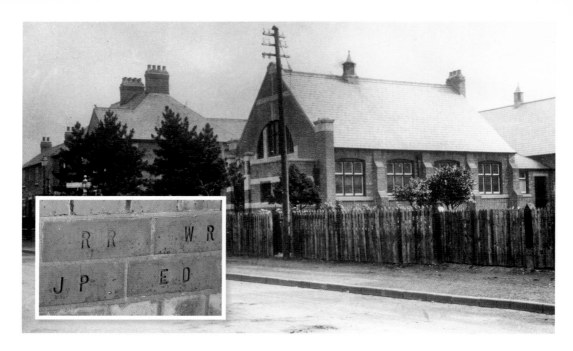

Ryton Methodist Church

There was an earlier Methodist chapel in Long Street before this one was built in 1911. The lower picture shows Jane Haywood, June Kelly, Pam Perkins and Pauline Marriott examining some of the church records at a special event held for the centenary in 2011. The inset shows initials of people who paid sixpence for a brick. Len Farndon, then ninety-eight, told me how he asked his mother for money to buy a brick. She refused on the grounds that they were Anglicans!

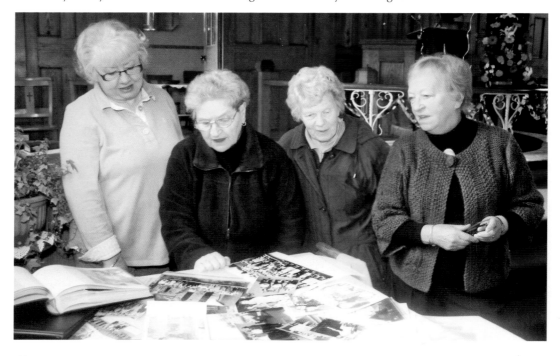

Village School
The lower picture shows the school as it was in February 1968. The village was collecting funds towards adapting the building for community and church hall use after the pupils moved to the new St James Junior School. Fifteen years later the front had been rebuilt to provide a hall space, and the horse chestnut tree is still there. It was to be felled soon afterwards.

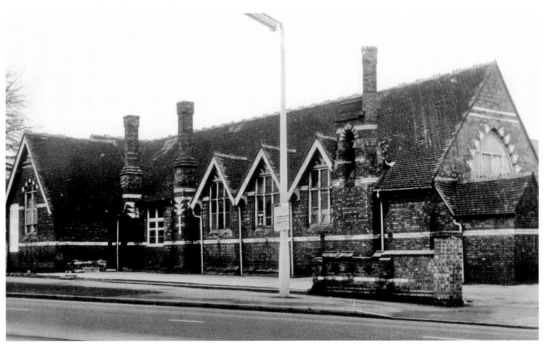

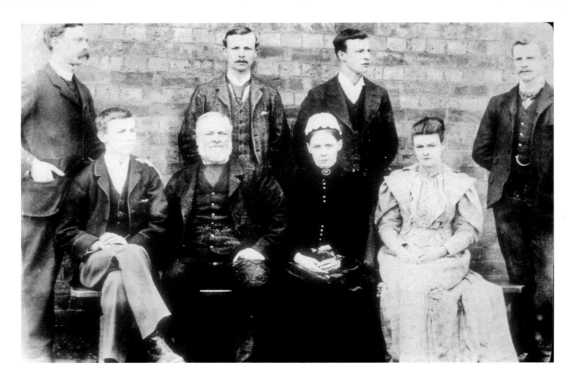

The Winterton Family

Thomas Winterton and his wife Esther ran the school for thirty-six years from 1862. A perk of the job was the school house, shown here, which stood where the library is. Their six children all had distinguished careers in the church and education. A contemporary report said that 'the big, rough lads, accustomed to have matters their own way, gradually yielded to the superior will, and were eventually effectively quelled'.

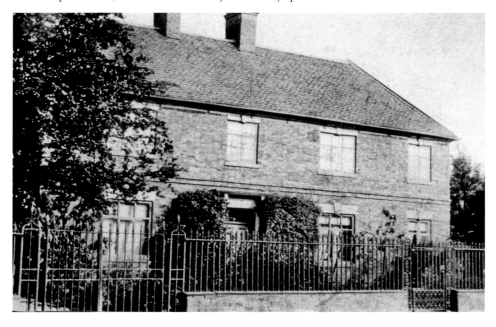

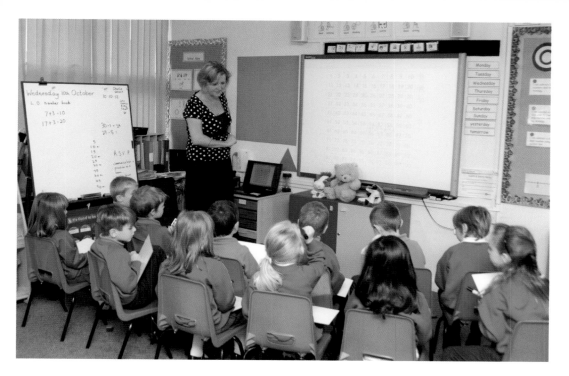

Schools Today

The top picture shows a group from Arden Forest Infant School looking at the whiteboard, which acts as a giant computer screen and has replaced blackboards and chalk everywhere. The lower picture was a special occasion for the children from St James Junior School. To celebrate their fiftieth anniversary they were photographed in front of a helicopter that arrived for the day.

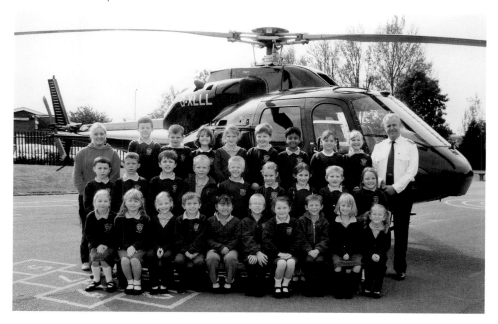

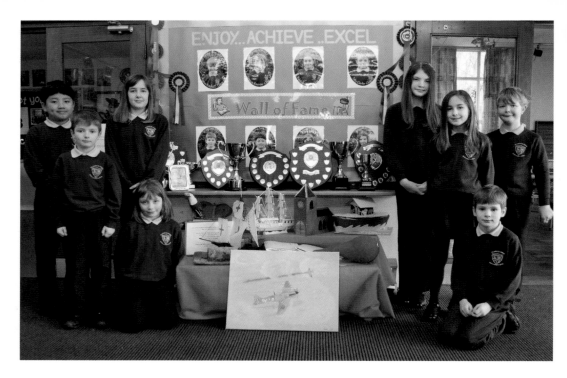

Sixty Years of Schools

The top picture shows some talented and hard-working pupils from St James in March 2013. They are the pupils who are on the wall of fame in the school entrance. They will now have a book to remember their achievements by. The bottom picture shows an infants' class in the late 1940s. They are in the new (1939) infant school, which is now the Village Centre.

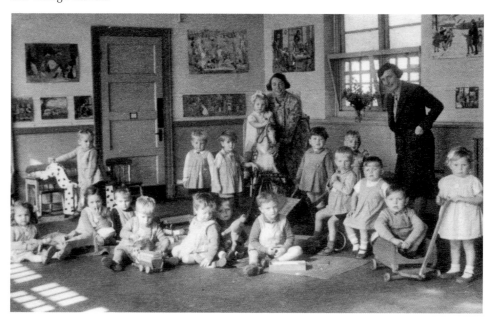

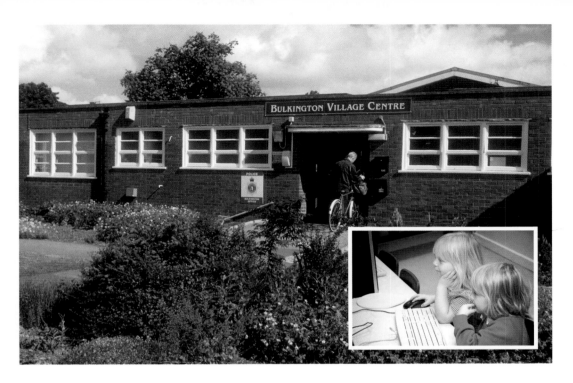

Infant School and Village Centre

The postman is delivering mail to the Village Centre, converted from the infant school. The colour scheme has changed since this picture was taken. The picture below shows the school in use for infants in the late 1940s, with teachers Mrs Elson and Mrs Breedon. The inset shows two children from Arden Forest Infant School at work on a computer.

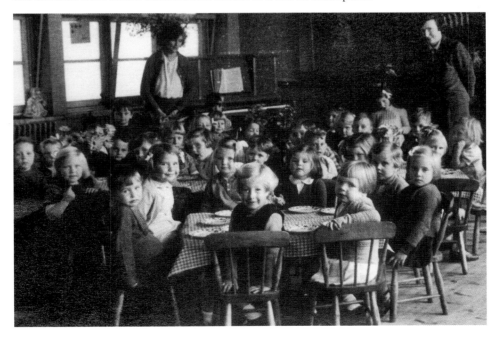

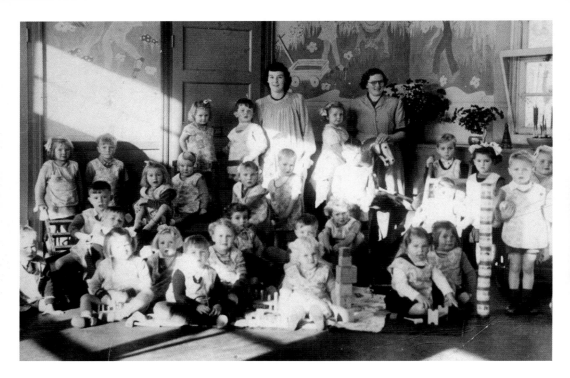

School Across Sixty Years

Another infants' class from the school in around 1948. The teacher is Mrs May Dawkins (*on the left*) and her helper is Mrs Carvell. The picture below shows pupils from St James Junior School in March 2013. An interesting contrast between then and now is seen on the walls. In the early pictures there are things on the walls but they are not done by pupils, whereas now the walls are packed with colourful work, all done by pupils.

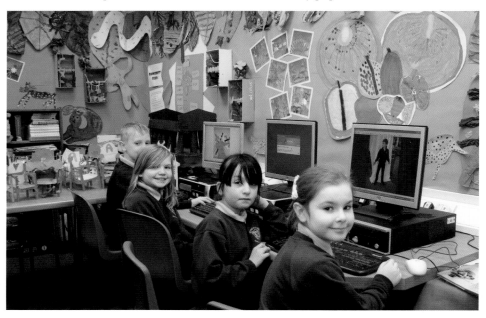

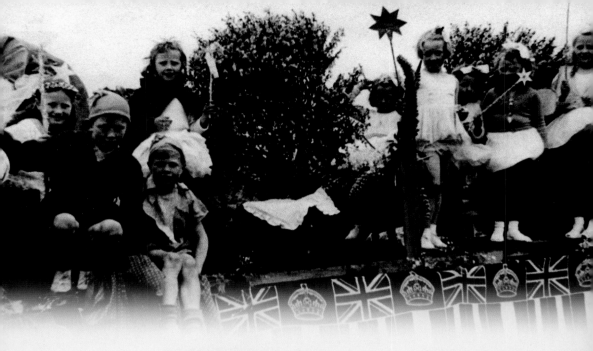

CHAPTER 5

Social Events

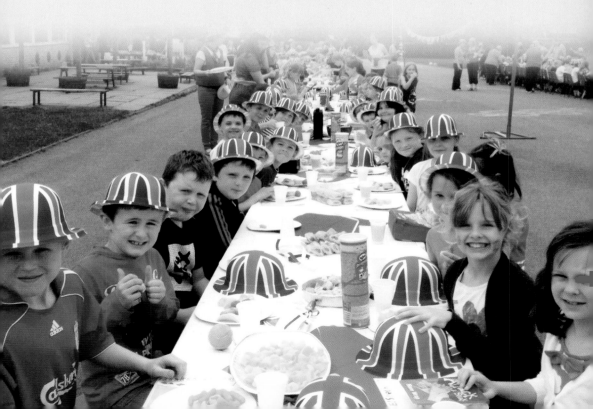

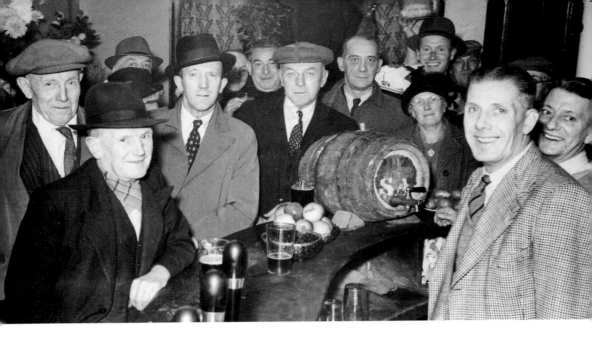

Getting Together

Page 75 illustrates royal influence on Bulkington. The top picture was taken on Coronation Day in 1953. The picture below, sixty years later, shows children from St James Junior School having an outdoor party, as their grandparents had done in 1953. On this page, customers in the 1950s enjoy a drink in the Crown Inn and a little girl makes a presentation to Lady Newdegate in the presence of Revd and Mrs Dingley and Reg Green.

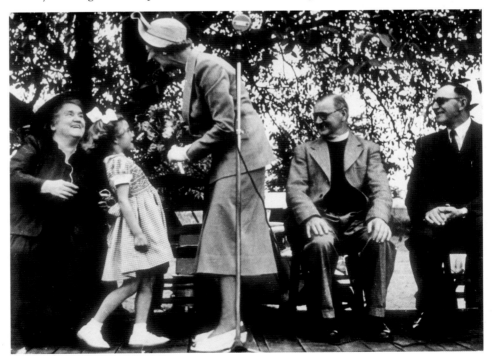

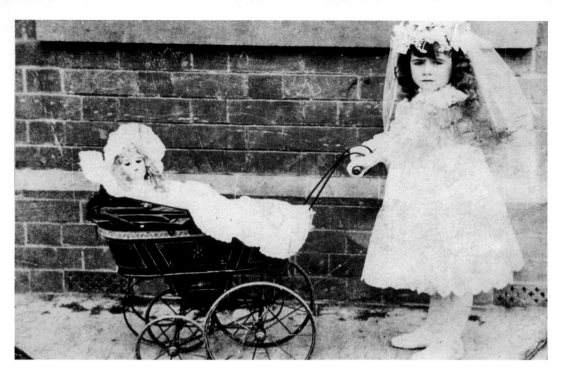

Coronation of George V

This lovely picture shows Dorothy Harrison (later Aldridge) during the celebrations of the Coronation of George V in June 1911. She and her doll's pram were near the corner of Leicester Street and School Road. The bottom picture, taken the same day, shows young Master Page holding the horse. One of the girls is his sister and the boy on the trap is Cuthbert Larkin, later a teacher and headmaster.

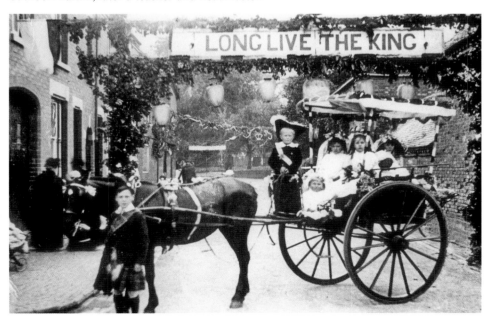

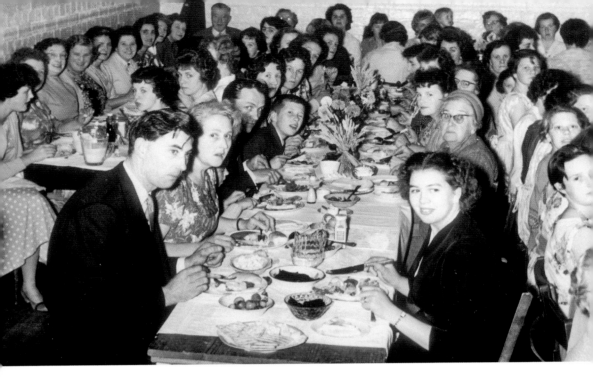

Suppers and Carnivals

In the 1950s and 1960s local ladies worked to provide meals for village events. The top picture shows the Harvest Supper in October 1959; a hearty and popular meal. There have been carnivals in Bulkington for decades. At times the committee flags, but people respond and every year it succeeds. In 2011 the WI celebrated the Land Army. On the right is Lucky Lewis, an indefatigable and popular worker who died during this book's preparation.

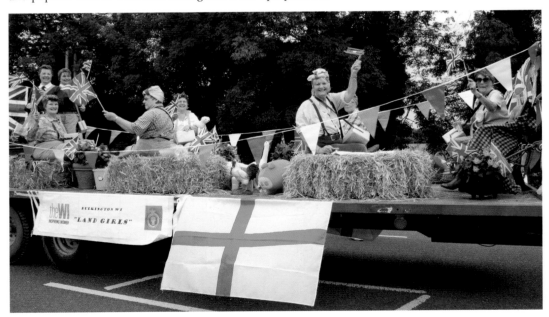

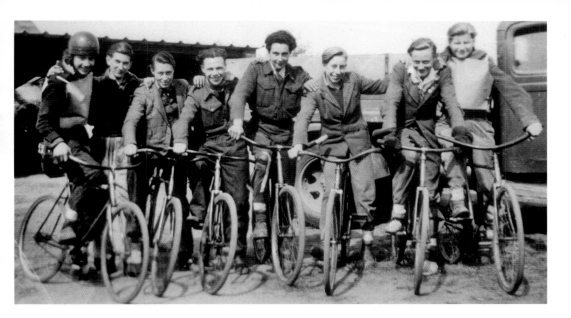

Sporting Endeavour

The top picture, from 1946–48, features the Bulkington Bulldogs or the Marston Mohawks, local cycle speedway teams. Left to right: Gordon Gibbs, Colin Wright, Keith Knight, Johnny Condon, Jeff Duggins, Jimmy Blackford, Tony Childs, Victor Greenway. Behind is the team transport, a Morris Commercial lorry from the Corner Garage. Below are three Olympians who now live in Bulkington, holding the 2012 torches. They are Basil Heatley (silver 1964), Sheila Carey MBE (1968 and 1972) and Ernie Crutchlow (1972).

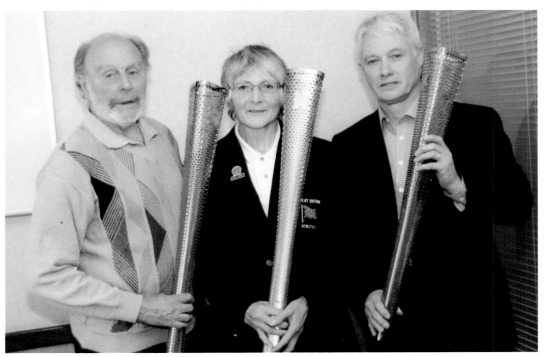

Life at the White Lion
The bottom picture seems to date from between the wars. It certainly shows how we dress down for relaxation these days when you look at the top photograph, taken on Carnival Day 2010. The revellers in the sepia picture are mostly wearing hats or caps, heavy shoes, ties and three-piece suits. Man-made fibre had yet to make its mark!

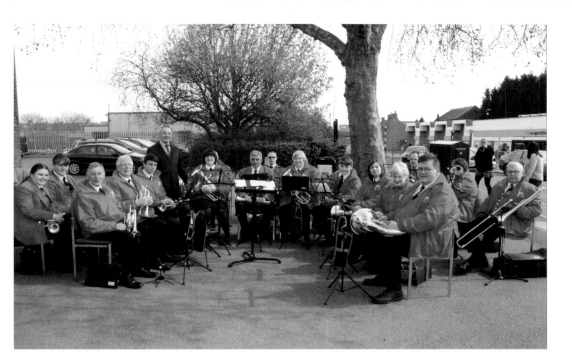

Bulkington Silver Band

There has been a brass band in the village since 1848 when George Bicknell started a band that included his five sons. Indeed it was known as Bicknell's Band until 1919. In the colour picture some of the band, under their leader Michael Taylor, played at the official opening of the Community Library on 14 April 2012. The bottom picture shows the band at the height of their success under Gary Smallwood in 1990.

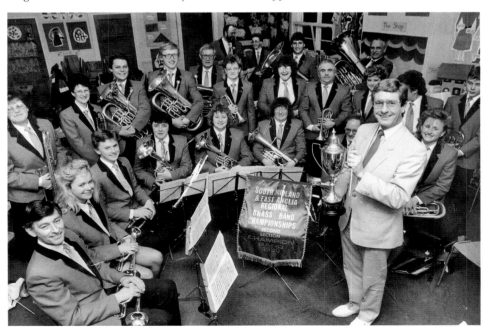

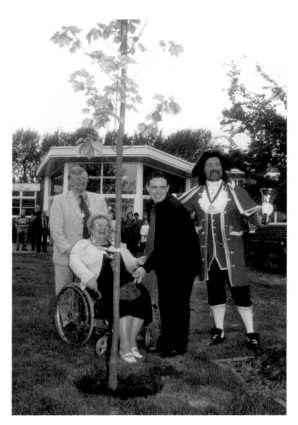

Trees and Gardens

Bulkington Village Centre is a triumph of local initiative, enterprise and determination. Enough people were inspired by the community centre concept in 1996 that it eventually came to pass. Some of those leaders later ensured the future of a library, which the County Council was prepared to abandon. The picture shows the official tree-planting at the opening of the Village Centre, which also won a Bedworth Society Award. Many local people have entered the Borough in Bloom competitions. We could have a complete section devoted to inspiring gardens in Bulkington, which has a thriving garden society. Mr Norman and his wife won everything for their garden in 2004 and amazed the judges with their skill and care.

Carnivals

Bulkington always enjoys its carnivals and has succeeded in keeping them going where other places have given up. It is typical of the spirit of the place and every year crowds line the streets, applaud the floats, participants and events on the recreation ground. I could fill the book with pictures of Bulkington carnivals but there is room only for a few samples. The picture shows Town Crier Paul Gough, ever the showman, leading the 2011 procession resplendent in his new uniform. The picture below takes us to the 1963 carnival queen and her maids. One significant difference over fifty years is the size of the lorries, which are now massive and a big challenge to those decorating them compared to earlier years.

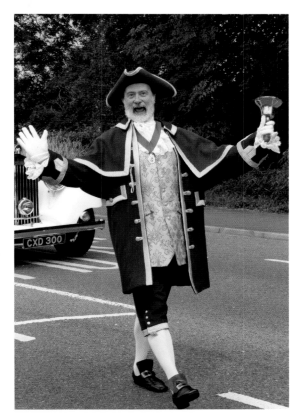

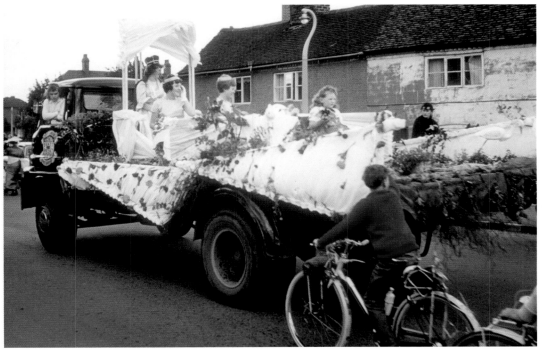

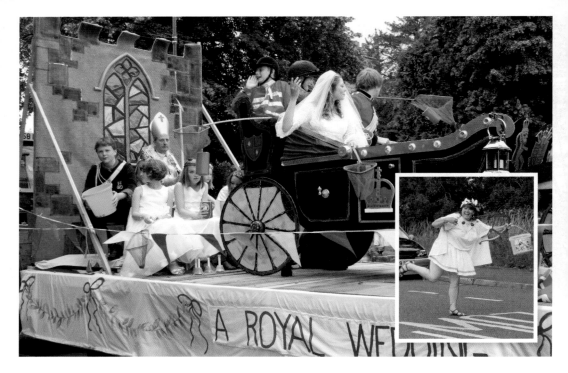

Carnival Fun

Topical events are often used in floats. The top picture will remind the reader that 2011 was a royal wedding year, and children will tell their grandchildren of the day they were Will and Kate! I'm not sure what the lady in the inset picture will say! But carnivals are for fun and families and the picture below shows the fun to be had when roads are traffic free and people do things together for the good of their community.

CHAPTER 6

Farming

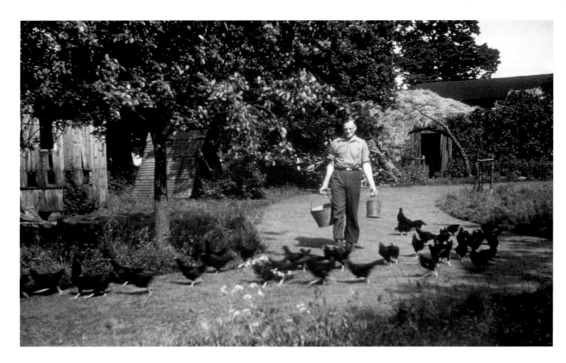

Snow in the Landscape

Page 85 shows the medieval open field at Galley Hill Fields in 1983. Snow melts first on the raised part of ridge and furrow, revealing old field patterns. The bottom picture is a Stan Allcoat photograph taken on his farm in 1962. This chapter is a tribute to Stan Allcoat, who recorded Bulkington in the 1950s and 1960s and also its farming life. Here Stan is seen feeding poultry in 1954, and below is a superb 1963 snow scene.

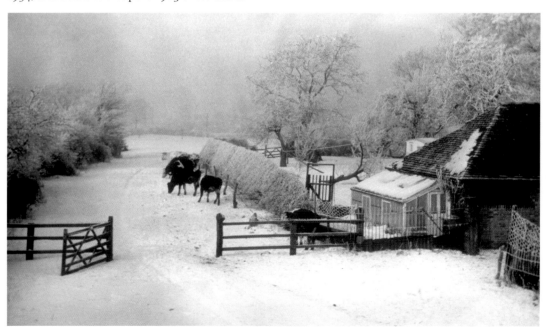

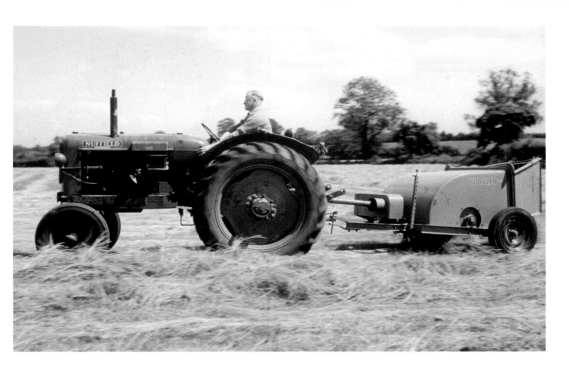

Life on the Farm

Stan Allcoat's farm was at the end of Long Street in Ryton. The farmhouse is still there but all the farm buildings have gone and houses and bungalows are on the site. Stan was a keen photographer. He was also interested in sound recording and was a pioneer in that field. The pictures on this page show Stan wuffling hay in 1961 and a group of potato pickers in 1957.

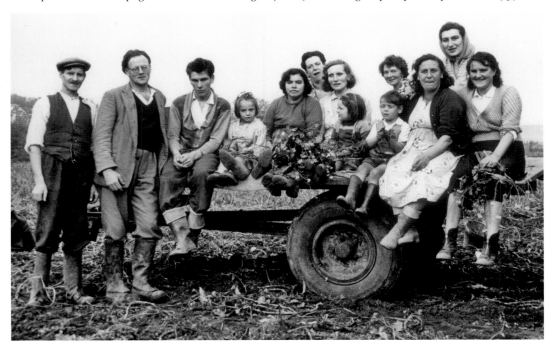

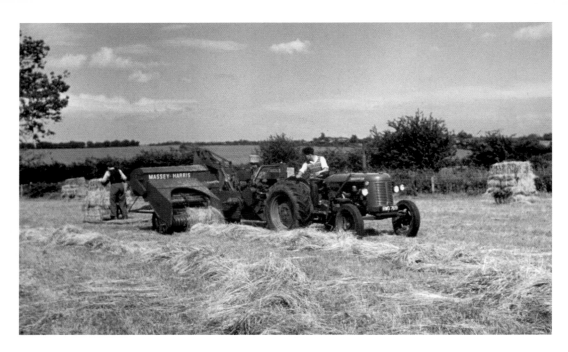

Making Hay

Most farmers are too busy to bother about taking photographs of themselves at work, so we are particularly grateful that Stan made the effort to record life on the farm. His is a unique collection that shows farming life in Ryton over a twenty-year span in the 1950s and 1960s. The pictures on this page show them baling the hay in Watergate field in 1956 and unloading the hay into the barn in 1961.

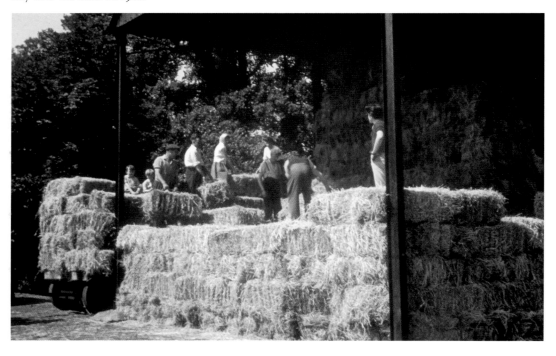

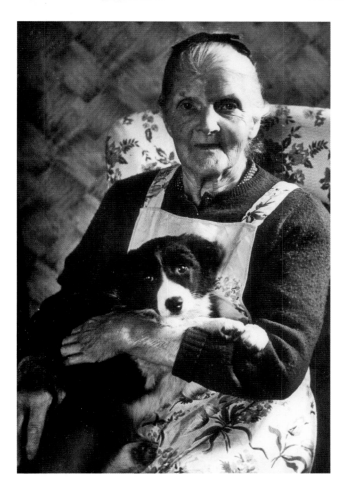

Portraits

The main picture shows Stan Allcoat's mother at the farm in October 1955, with the farm dog Betty. This is a photograph of the highest quality, worthy of the portrait work of the best professionals. It was taken by Stan, whose portrait is below.

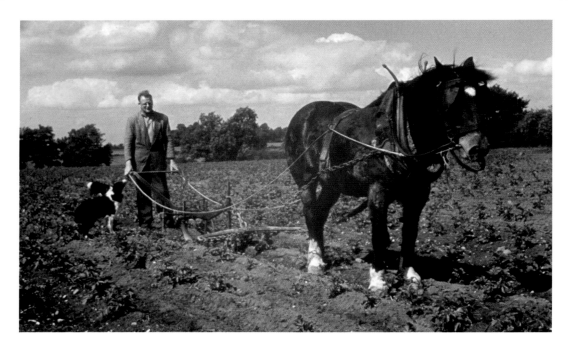

Work on the Farm

It is easy to forget how labour intensive farming was until comparatively recently. All farms had horses to work the land and to carry things. One picture here shows Stan Allcoat and Tommy the horse hoeing in a potato field in 1960. The other picture shows Stan hedging in 1960, a skilled and laborious job now undertaken by a worker using a tractor and attachment that cuts many yards of hedge in a day.

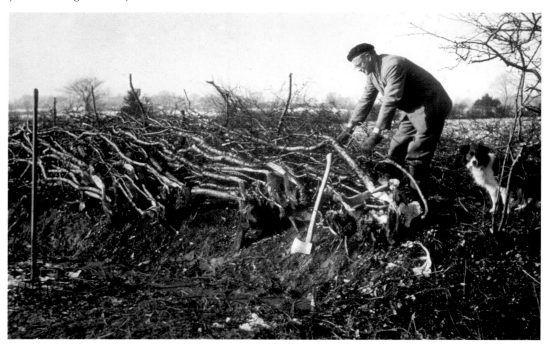

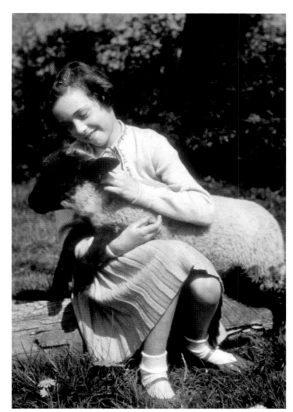

People on the Farm

The colour portrait is of Valerie Pegg nursing a lamb in 1956, and the picture below shows hay time at Milner's Farm in Ryton. Mr Milner, in his three-piece working suit, ran a farm in Ryton. The present Milner Close is on the site of his farmhouse. Second from the right is Stan Allcoat and the picture was taken on 7 July 1960.

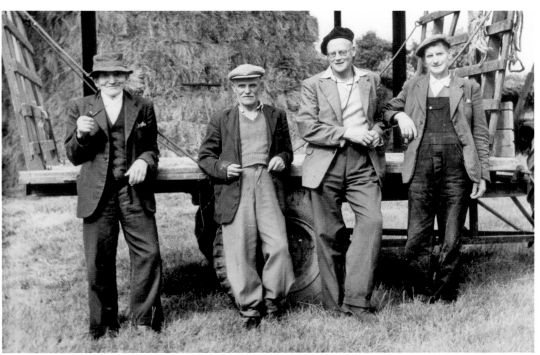

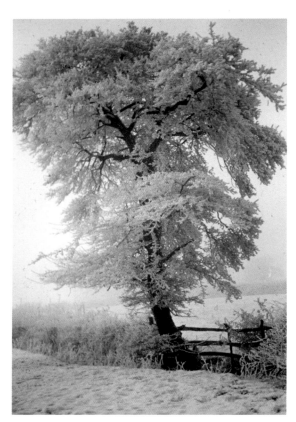

Contrasting Seasons

Farmers are always up and about early in the day, and Stan Allcoat was able to capture the wonderful effect of hoar frost on this tree one morning in early 1959. The picture below shows the workers and helpers at harvest time on the farm later the same year. Harvesting was hot, sweaty work in the summer heat on 7 August 1959.

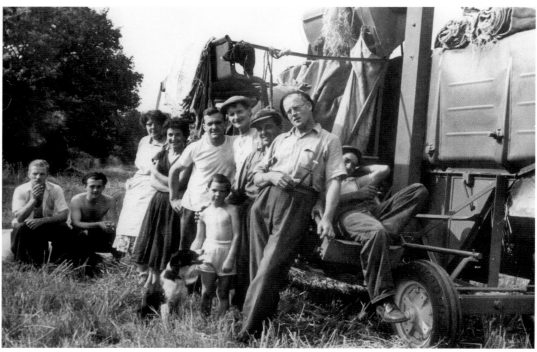

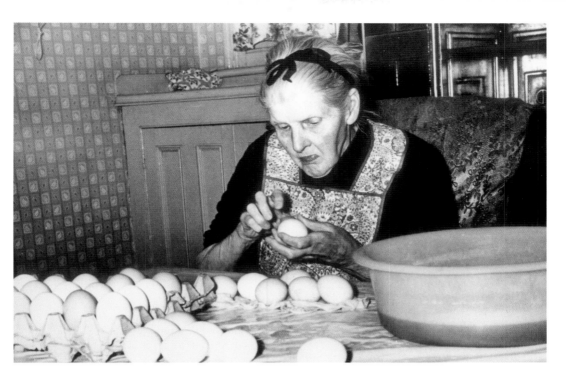

Work on and in the Farm

The picture inside the farmhouse shows Stan's mother washing eggs on 10 February 1958. She is looking frailer than in the portrait taken in 1955, and she was to die the following year. The colour picture shows the men combining the wheat in 1960.

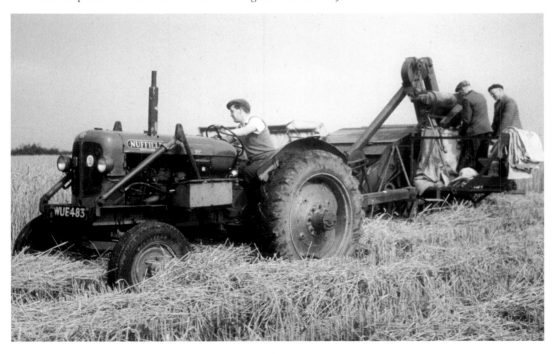

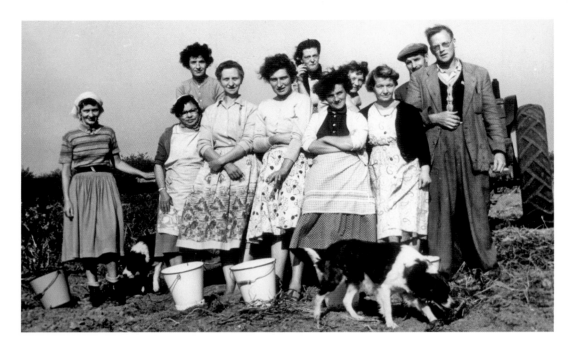

Potato Picking and the Farm

I remember potato picking in the late 1950s to earn money to buy a good camera. I still recall the backache it caused and the agony of cycling home! These village people were earning extra money from potato picking on Stan Allcoat's farm in October 1959. The other picture shows the farmyard in 1966. It looks run down, and by the mid-1960s mixed farming was becoming harder to make a living from.

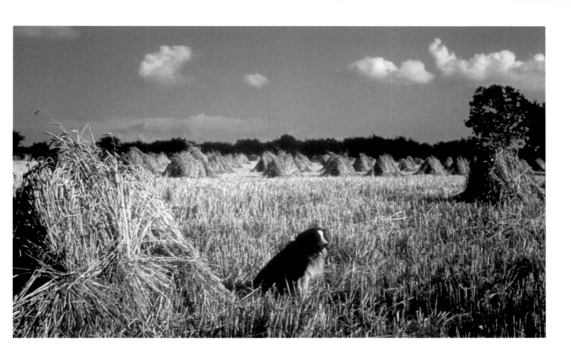

Crops in the Fields

The field with sheaves or stooks of wheat is not one we see today. This is one of Stan Allcoat's earliest pictures, dating from 1954. It is a picture full of charm and nostalgia, but the way of life it reflected was disappearing and Stan would not recognise pictures like the one below. Oil seed rape is grown on farms around Bulkington and changes the appearance of the landscape in a startling way every spring.

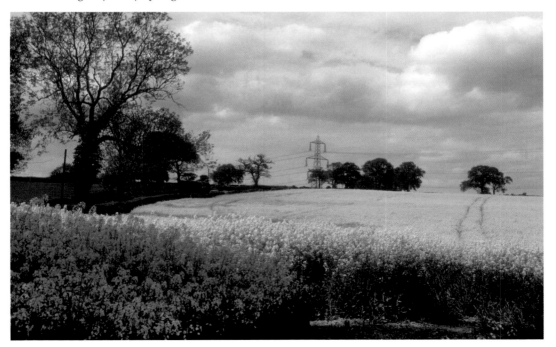

Acknowledgements

I have been allowed to use photographs, and gained information from, many people over the last thirty years. In particular I thank Kay Farndon for much new information and many corrections to my first book (Sutton, 1990), which are now archived. Leon Gibbs has been enormously helpful in granting access to some new material from Stanley Allcoat and giving details of other pictures. Thanks also to Paul Messam for allowing me up the church tower, to Paul Ison and Jeanette Hiatt for photographs from their schools, and to many individuals who loaned photographs or provided information: Jean Cooper, Brenda Friswell, Andy and Shirley Axon, Pam Perkins, Arthur Farndon, Alwyne Bassett, Barry Chedlow and to the many people I have photographed who have not complained!

I am deeply grateful still to the many people who helped and supported my first book of Bulkington pictures, for their efforts then have made the second book possible. They include May Dawkins, Mary Goodland, Geoff Edmands, Mrs Ashley, Dorothy Blundred, Mrs Turner, Reg Green, Mr Taylor, Mrs Spencer, Gordon Morgan, Sheila Gernon, Joan Uren, Michael Smith, Ralph James, Stan and Margaret Clarke, Mrs White, Dorothy Aldridge, Darrell Buckley, Reg Neale and Lynda Burton. And, of course, Dame Fripp and her pig.